AN INTRODUCTION TO
ARABIC
CALLIGRAPHY

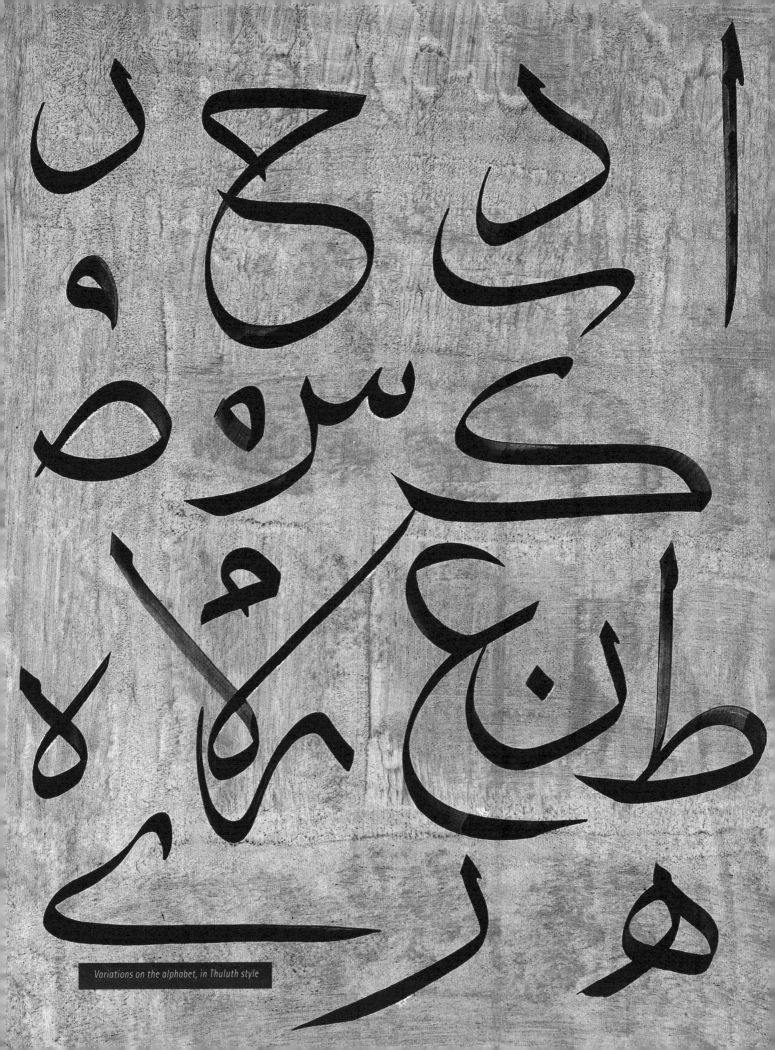

Variations on the alphabet, in Thuluth style

AN INTRODUCTION TO
ARABIC
CALLIGRAPHY

GHANI ALANI

4880 Lower Valley Road • Atglen, PA 19310

Other Schiffer Books on Related Subjects:

An Introduction to Calligraphy, Véronique Sabard, Vincent Geneslay, and Laurent Rébéna, ISBN 978-0-7643-5230-0

An Introduction to Chinese Calligraphy, Lucien X. Polastron and Jiaojia Ouyang, ISBN 978-0-7643-5242-3

An Introduction to Japanese Calligraphy, Yuuko Suzuki, ISBN 978-0-7643-5218-8

Original edition's graphics and layout: Claude Poirier
Cover illustration, main character: "El Khatt" (Arabic, "the art of the line") calligraphed by Ghani Alani
Grateful acknowledgment to the Réunion de Musées nationaux for the images reproduced on pages 8 & 9.

Type set in Trajan Pro/Adobe Garamond Pro/Syntax

ISBN: 978-0-7643-5173-0
Printed in China

Published by Schiffer Publishing, Ltd.
4880 Lower Valley Road
Atglen, PA 19310
Phone: (610) 593-1777; Fax: (610) 593-2002
E-mail: Info@schifferbooks.com
Web: www.schifferbooks.com

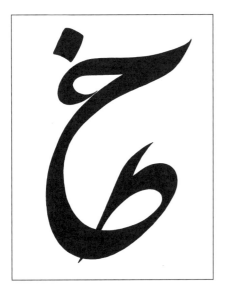

For our complete selection of fine books on this and related subjects, please visit our website at www.schifferbooks.com. You may also write for a free catalog.

Schiffer Publishing's titles are available at special discounts for bulk purchases for sales promotions or premiums. Special editions, including personalized covers, corporate imprints, and excerpts, can be created in large quantities for special needs. For more information, contact the publisher.

We are always looking for people to write books on new and related subjects. If you have an idea for a book, please contact us at proposals@schifferbooks.com.

CONTENTS

TO GHANI ALANI

In script, if an ellipse is a line of fire from thought, I would like to associate letters to the ellipse. Place them on the same level without it having to unveil itself—a level of tension, passion, and imagination, the violent and secret life that is given a voice by ink and a qalam (reed pen), by a hand and an eye, called calligraphy. It reveals the person who lives and dictates its lines, its architecture, its imaginary and abstract composition, which, as soon as they are laid down, become life itself. Strictly ordered with an implacable algebra and ceaselessly renewed inventions, incised without error or influence, dances and thoughts, paint that precisely expresses the beauty of words and a language on several levels, calligraphy is perhaps the first form of the arts, the one that fixes the spirit with a sign and, verba volant, signs and inscribes speech in the definitive, a trajectory toward the essential.

In truth, all calligraphy is a constant poem of deep thought, a poem of complicity between the eye and the soul. A living geometry that is ceaselessly reinvented, it expresses through its initials, a heart of hearts "as close to man as is his jugular vein," the most revealing line that hides and shows—to an incredulous heart, according to Verlaine—its sobriety and its luxury, its rigor and its extravagances. Neither Gothic nor Roman script in the West have ever reached this flexibility, this virtuosity, this movement, these compositions and skills which make it, with a single line, an object of beauty and power. Also an object of violence: any calligrapher is "the son of the white of the eye" after Ibn Muqla, who, in the tenth century, had his right hand cut off and, because he continued to write by attaching a qalam to his wrist, had his tongue torn out by the Vizier Ra'iq.

Qualified at the School of Baghdad, Ghani Alani has linked his work and his name to a fascinating tradition, that of a script that is Man himself. He has gone further. He has dedicated his personal genius to Mankind and to Beauty.

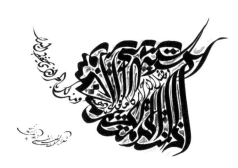

▲ *Poem about generosity by Al-Mutanabbi, 914–965 CE (in the year of Hegira 303–354). Tughra, 90 x 60 cm.*

Pierre Seghers

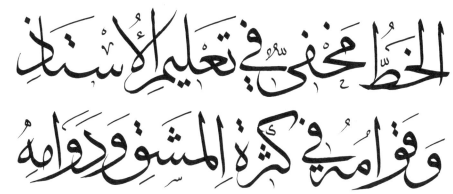

"The calligraphy is hidden in the master's teaching, but its existence is in the abundant repetition of exercises and in the constancy with which we apply ourselves to it."

INTRODUCTION

Historically, script began as drawings, in the shape of pictograms: the meaning was drawn rather than written. Today, in a reverse of that order, I use calligraphy for drawing, to create an image. Calligraphy has become the art of "the image of the word."

This book is about the art of Arabic calligraphy, its theoretical, analytical, and practical aspects. However, the word "calligraphy" shouldn't be taken in its literal sense, that of "the art of properly forming written characters." For Arabs it means the "art of the line," el khatt. This art hasn't only written the Arabic language, but also many other languages that have adopted the same alphabet, such as Persian or Turkish, following the spread of Islam.

This flexibility of adapting has given an extraordinary richness to an art which can rightly be qualified as "Islamic," because each Islam society has contributed to its evolution. This explains the fabulous variety of styles, in both manuscripts and architecture.

I can't possibly show all the different forms in this book, as they are unlimited, nor can I cover all the teachings of masters in the art, as this book is a simple introduction, open to everyone. You will learn how to choose the right materials and prepare your tools for working properly. Then you'll become acquainted with the major graphic styles: Kufic, Thuluth . . . Before you begin, I'd advise you to familiarize yourself with the vocabulary and terms that are specific to calligraphy. The glossary on page 79 will help.

Apprenticeship starts by tracing the isolated form of the letters. This is followed by assembling the letters and, finally, words and phrases. Once most of the techniques have been learned, the student can turn to the numerous styles and choose to work on a particular one. Mastering the basics is the only thing that will allow you to eventually surpass the rules of calligraphy to imagine your own personal compositions and to create your own style. It isn't the imitation of, but the respect for, the rules laid down by masters of the art, elaborated over centuries, that allows future generations to acquire the freedom and the power to help this living art progress. The master gives his new apprentice the "clay" to model it as he wishes, to create a new form.

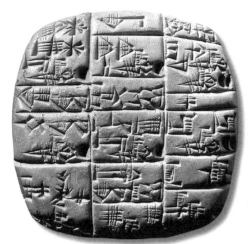

FROM SCRIPT TO CALLIGRAPHY

◀ *Sumerian script around 3500 BCE.
An economic tablet recording the
sheep and goats destined for sacrifice.*

What is script?

The birth of script

Script is defined as a system of conventional signs that allow communication to be fixed between people. We can expand this, as Gérard Blanchard has, to include "all marks, lines, numbers, tattoos, drawings, signs . . ." He continues by stating that "the most ancient traces of humanity are sacred signs, linked in some way to religious practices that we don't know about . . . They are the finger-paintings left in prehistoric caverns, the Chinese symbols engraved on turtle scales, the hieroglyphs carved on the walls of the tombs of ancient Egypt . . ."[1]

So, the desire to conserve a piece of information, a thought, or a feeling, created various forms of notation at the dawn of humanity, among which was script—in the sense of a system capable of immortalizing speech or thoughts. This system has been raised to the rank of an art in itself, by calligraphy.

Writing first appeared around 3500 BCE in Mesopotamia, at Uruk, a Sumerian city in the fertile crescent region that lies between the Tigris and the Euphrates rivers.

The Sumerians came up with an answer to their recordkeeping needs by representing certain objects in a schematic way on freshly made clay tablets, using a sharpened reed: what we call cuneiform. This was the first system of labeling merchandise and keeping economic and administrative records.

Later, the first literary works appeared, including the Epic of Gilgamesh, King of Uruk, written in 2100 BCE. Undoubtedly the best known early text is "Hammurabi's Code," engraved on a diorite stele in around 1750 BCE; it's in the Louvre in Paris.

1. Excerpted from the catalog *Ghani Alani, calligraphies,* edited by the Musée d'Histoire de Besançon during the 1980 exhibit.

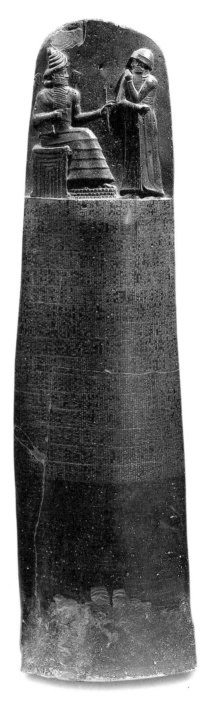

▲ *Stele depicting the code of laws of Hammurabi.
Babylonian era (eighteenth century BCE).*

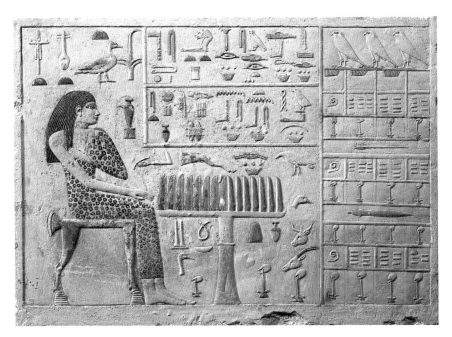

▲ *Stele of Nefertiabet, Ancient Empire (around 2700–2200 BCE).*

The Sumerians' invention spread throughout Mesopotamia. Egypt adopted it in turn, around 3000 BCE, but introduced new symbols, which set their hieroglyphs apart from the Sumerian script.

In spite of this extraordinary early success, Sumerian, a difficult language, was replaced by Akkadian as the lingua franca of ancient Iraq. The Akkadian script, the last stage of cuneiform, was in turn replaced by Aramaic.

The Aramaic language developed in the region of what are now the Syrian cities of Damascus and Aleppo, in around the first century BCE. It was written from right to left. It enjoyed a remarkable distribution: we find Aramaic inscriptions in Asia Minor, Afghanistan, and even in the Punjab. Aramaic gave birth to numerous scripts, without a doubt because of its ability to integrate a key invention that appeared in around 200 BCE: an alphabet of twenty-two letters, capable of replacing hundreds of signs in use at the time.

Much later the Arabic script was born from these first scripts, and it entered the large family of scripts that had Semitic origins, like Aramaic script, the Canaanite scripts (of which Hebrew is one), and the Syriac script, which undoubtedly developed from the Akkadian script.

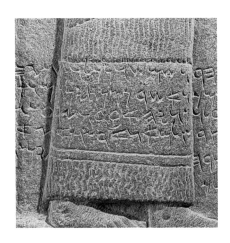

◀ *Detail of a basalt stele representing a praying priest. Inscription in Aramaic (seventh century BCE).*

THE ORIGINS OF ARABIC SCRIPT

The first inscriptions that showed signs of the Arabic language were done by Nabateans.

According to paleographers, Arabic script derives from Nabatean script.

Because the Nabateans were an Arabic people (today's historians agree on this point), we can say that there's an unbroken continuity all the way from Aramaic script to the Arabic script at the time of the beginning of Islam, which is close to today's Arabic script.

Aramaic

Nabatean

Kufic

Arabic today

▲ *Evolution of Arabic script, from Aramaic to today's Arabic. By the author, taken from the 109th chapter of the Koran, "The Unbelievers."*

The basics

الخط العربي

Arabic script is written from right to left.

The alphabet has 29 letters, drawn from 19 initial forms.

The number of characters needed is reduced through a system of dots.

The letters can be linked on both sides, except for four letters: Alif, Dal, Ra, and Wau. (See the diagram on the following pages.)

←——— Direction of reading: from right to left.

ش س ز ر ذ د خ ح ج ث ت ب ا

ي لا ه و ن م ل ك ق ف غ ع ظ ط ض ص

▲ *The 29 letters*

ل ك ق ف ع ط ص س ر د ح ب ا

ى لا ه و ن م

▲ *The 19 forms*

The letter contains a part for reading, and an extra part, which is removed if the letter is used at the beginning or in the middle of the word; but which appears if the letter is used at the end of a word.

Connected letter

Complementary part

Vocal part, for reading

Isolated letter

Arabic script doesn't have written short vowels, so it has (optional) vowel symbols that indicate those sounds:

Dhamma vocalization of [su]

Fatha vocalization of [sa]

Kasra vocalization of [si]

- fatha: vocalization of [a]; a short vowel sound, like the a in "hat"
- kasra: vocalization of [i]; a short vowel sound, like the i in "hit"
- dhamma: vocalization of [u]; a short vowel sound like the u in "hut".

Example, above: Jim with vocalization marks.

The basics of Arabic script in Naskh style

When letters are connected they get a few modifications, sometimes slight, sometimes more major.

The letter hasn't undergone a great deal of change in terms of its initial form.

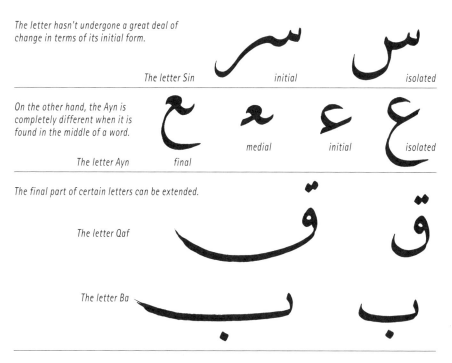

The letter Sin — initial — isolated

On the other hand, the Ayn is completely different when it is found in the middle of a word.

The letter Ayn — final — medial — initial — isolated

The final part of certain letters can be extended.

The letter Qaf

The letter Ba

The letter Kaf changes its form at the beginning and the middle of a word, but it regains its initial format at the end of a word with its two parts, principal and secondary.

The letter Kaf — final — medial — initial — isolated

Note that although all the modifications aren't required for regular writing, they must be absolutely respected in calligraphy, especially in the Thuluth style. This explains why certain letters show varied forms, such as Ra.

The letter Ra

And the numbers . . .

This written form of the numbers is current in many countries in the Middle East. This form is suitable for all the styles of calligraphy.

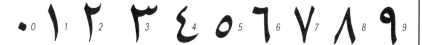

٠ 0 ١ 1 ٢ 2 ٣ 3 ٤ 4 ٥ 5 ٦ 6 ٧ 7 ٨ 8 ٩ 9

Final	
The same letter connected 3 times	With a letter
١١١	ـا
ببب	ـب
ججج	ـج
ددد	ـد
ررر	ـر
سسس	ـس
صصص	ـص
ططط	ـط
ععع	ـع
ففف	ـف
ققق	ـق
ككك	ـك
للل	ـل
ممم	ـم
ننن	ـن
ووو	ـو
ههه	ـه
لالالا	ـلا
ييي	ـي

Medial		Initial		Isolated	Transcription	Letter name
Special	Ordinary	With horizontal or descending letter	With vertical			
	ا		Isolated form ا	ا	Alif	الف
بد	بہ	بر	بـ د	ب	Ba*	باء
جـ	جـ	جـ	جـ جـ	ج	Jim*	جيم
	د		Isolated form د	د	Dal*	دال
	رں		Isolated form ر	ر ں	Ra*	راء
سـ	سـ	سـ	سـ	س	Sin*	سين
صـ	صـ	صـ	صـ	ص	Sad*	صاد
	طـ	طـ	طـ	ط	Ta*	طاء
	عـ	ء	عـ	ع	Ayn*	عين
	فـ	فـ	فـ	ف	Fa	فاء
	قـ	قـ	قـ	ق	Qaf	قاف
سكـ	كـ	كـ	كا	لـ ك	Kaf	كاف
لـ	لـ	لـ	ل	ل	Lam	لام
ح	مـ	مـ	مـ	مـ م	Mim	ميم
نخ	نـ	نـ	نـ	ن	Nun	نون
	و		Isolated form و	و	Wau	واو
ھـ	ھـ	هـ	هـ	ه	Ha	هاء
	لا		Isolated form لا	لا لا	Lam-Alif	لام الف
يد	يـ	يـ	يـ	ي ىـ	Ya	ياء

THE MATERIALS

1. *A reed:*
it's best to use its base, which is sturdier than the rest of the stem.

2. *Different-sized qualams (reed pens).*

3. *Small board, for writing large characters:*
the best wood comes from the cashew tree.

4. *Lampblack:*
a black ink base, ideal for exercises. You can also make your own colored inks from natural pigments.

5. *Gum arabic:*
when it's diluted in water, it acts as a binder to fix the ink to the paper, and also gives a bit of luminosity.

6. *A weight, used for crushing the pigments with the gum Arabic and for mixing colors.*

7. *Silk threads:*
these help to keep the qualam from hitting the edge of the inkpot (which risks breaking the tip), and help in picking up the correct amount of ink.

8. *Inkpot with silk thread.*

9. *Traditional inkpot:*
the largest reservoir contains black ink, and the other sections are for colored inks used for writing vocalization marks (the "dots" that show the vowels).

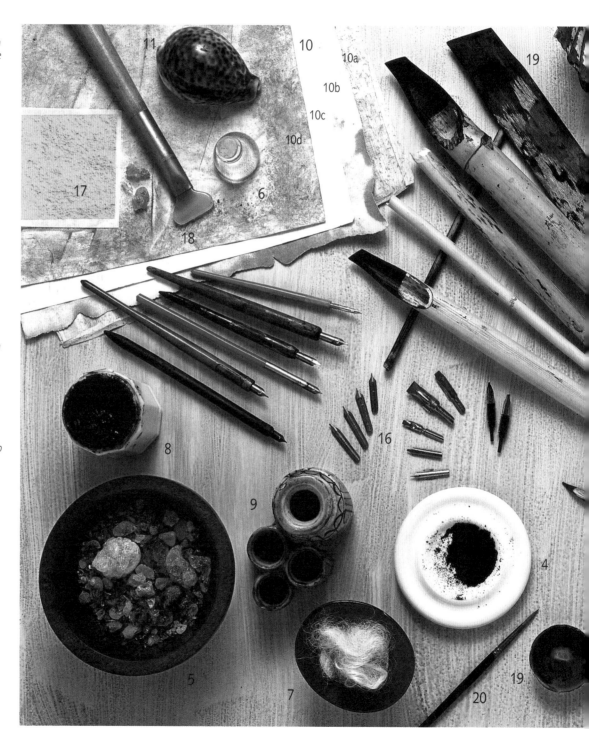

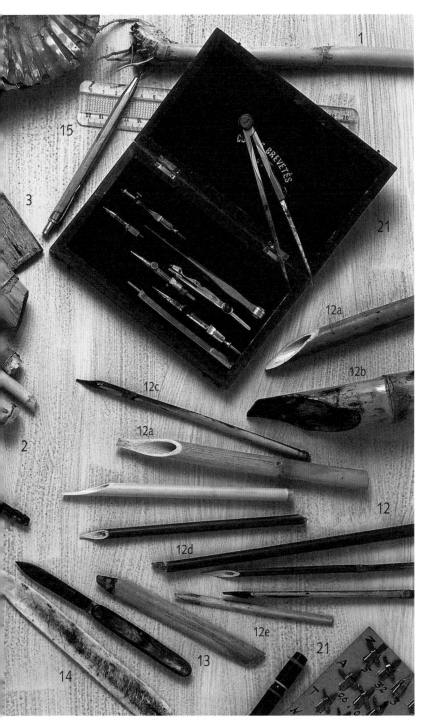

10. *Papers: papyrus (a), parchment (b), handmade paper (c), coated paper (d).*

11. *Shell for smoothing the paper. Any smooth object will work.*

12. *Qalams with different cuts. Each type is used for a precise written form: Persian (a); large characters (b) (the one shown here has been in use for over twenty-five years); small characters (c); Thuluth (d); Maghrebi (e) (for this style, the cut runs along on the entire width of the reed).*

13. *Well-sharpened knife, for trimming the reeds. Masters of the art advise using the knife for only this one purpose.*

14. *Miqat: the cutting surface used to split the reed to create the qalam. Traditionally a miqat was made of ivory to avoid damaging the knife's blade. The one shown here has been passed from master to master and bears the signs of thousands of cuts.*

15. *Ruler and pencil for drawing straight lines.*

16. *Metal pen nibs: some people prefer using ink pens over qalams, for example, when they are doing calligraphy of a long text, since this helps maintain regularity in the lines from the beginning to the end of the text.*

Materials for illumination

17. *Gold leaf: mainly used in illuminated manuscripts. It's heated, which gives it a darker tint, and then rubbed to make it glow again.*

18. *Scraper, mainly used on gold leaf.*

19. *Palettes to hold various colors of inks.*

20. *Brush: An extra-fine brush is used for emphasizing filled areas with a barely visible black outline.*

21. *Drafting tools, used for geometric drawing: compass, drawing instruments, etc.*

The qalam

The calligrapher's main tool is a simple reed that can be found in large quantities in warm, marshy areas. It has been used by humans since time immemorial.

Charming and melodious in a musician's hands, raw material for an architect, a pipe to water the earth for a Mideast farmer . . . a reed is an extension of the body, the hands, and the soul of a calligrapher.

This modest tool, used by poets long before Islam existed, gave its name to the "Surat al-Qalam, " "The Pen." It is the 68th sura (section or chapter) in the Koran, which begins: "By the pen and what the (angels) write . . ."

The choice of qalam

A calligrapher uses a reed that is neither too rigid nor too soft. My master, El Badadi, told me to choose one following the old adage advising a man to avoid being "so hard that he can be broken, or so soft that he can be squeezed."

The qalam has three elements:

A bright, smooth coating, called the "bone," on the outside; a porous part on the inside, called the "fat," that's removed; and, between the two, a more fibrous layer called the "flesh."

The art of making a qalam

Shaping and sharpening the qalam is an art in itself, because a properly shaped nib is an absolute necessity. Its width normally corresponds to half the reed's exterior diameter.

To shape the qalam, use a well-sharpened knife with a fine blade, and a nib-cutting surface, or miqat, made of bone (or ivory, if you are using an antique one). Avoid wood or metal, which could damage the knife.

Work in four steps:

Opening, sculpting, slitting, and cutting.

Opening

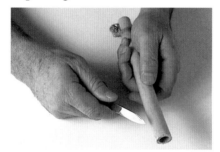

Start the qalam at a height equal to its circumference. The circumference is easily measured with a piece of string.

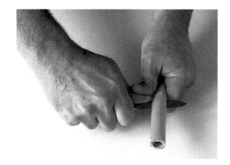

Cut crosswise, obliquely in a single stroke, to half of the reed's width, and continue toward the top, adjusting the blade as you go according to the thickness of the reed.

Sculpting

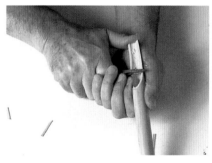

Thin out the reed's diameter and width so that the three parts (bone, fat and flesh) remain, the flesh being protected by the fat and the bone. The porous flesh absorbs the ink while the bone repels it, which gives a rich surface for the ink to interface with.

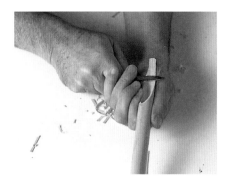

Along the width, reduce the exterior edges of the nib in an equal way until they measure about half the diameter of the reed. Each of the two edges looks like the shape of a sword.

Slitting

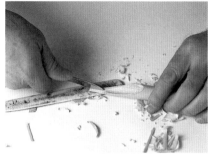

Usually, qalams have a slit in the middle. If the reed is harder, make the slit longer; on the other hand, if the reed is softer, make the slit shorter.

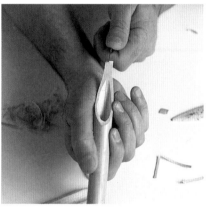

Cutting

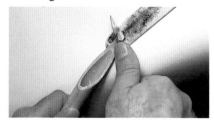

Cutting the nib is a decisive step, because this is what determines the qalam's writing point, which in turn specifies the type of line the qalam will create. Generally, the cutting angle ranges from 40 to 60 degrees.

In the sections on the different styles of script, we'll cover more details about cutting the nib.

The parts of the qalam

Knowing the names of the qalam's different parts will make it easier to understand the writing techniques. A sharpened qalam has a "front" and a "back." The front is the open side; the back is the opposite side, smooth and shiny. The sharpened part is called the "head." The flat part of the nib is called the "full." It has an acute angle (the "top tooth") and an obtuse angle (the "bottom tooth"). The edge you see by turning the qalam 90° from the full is called the "upstroke." The qalam should be wiped after use because the accumulation of ink on the nib expands and weakens it.

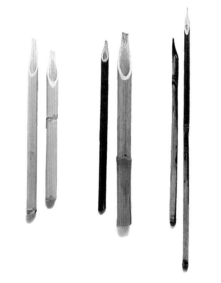
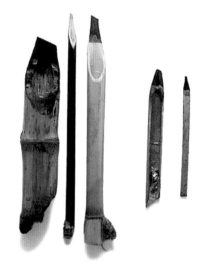

The metal-nib pen

It's also possible to use a metal-nib "dip pen," especially for smaller works.

Some are even manufactured specifically for Arabic calligraphy.

They come in different thicknesses, and you can sharpen them with a whetstone to get the right angle. (Remember, Arabic calligraphy is written from right to left.)

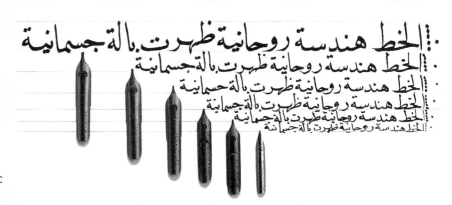

Ink

Traditionally, a calligrapher always prepares his own ink.

Black ink is made from soot (or lamp black) and gum Arabic dissolved in water, and mixed together in an inkpot containing silk threads. Other substances that produce other colors can be used, like stain made from walnuts. Long ago, the ancients also used natural pigments to highlight titles, and for decorating their work.

The ink you use for practicing should be neither too thick nor too thin and watery, because its transparency is part of what reveals the energy of the letters.

Starting as a beginner, before you spend time to gain experience in making your own ink, you are usually better off buying the already-prepared liquid ink sold in arts and crafts stores. And beginners today can choose to use a natural sponge in place of the silk threads that are traditionally used with the ink.

Paper

Arabs first used rigid supports (bone, wood, or stone) or cloth for their calligraphy surfaces. The famous *Mu'allaqat*, a group of seven treasured pre-Islamic Arabic poems, would have been transcribed in gold letters on bands of Coptic linen and suspended on the Ka'aba, the Black Stone at Mecca. At the beginning of Islam, the Koran was also written on various materials (bone, skin, parchment) before being written on paper.

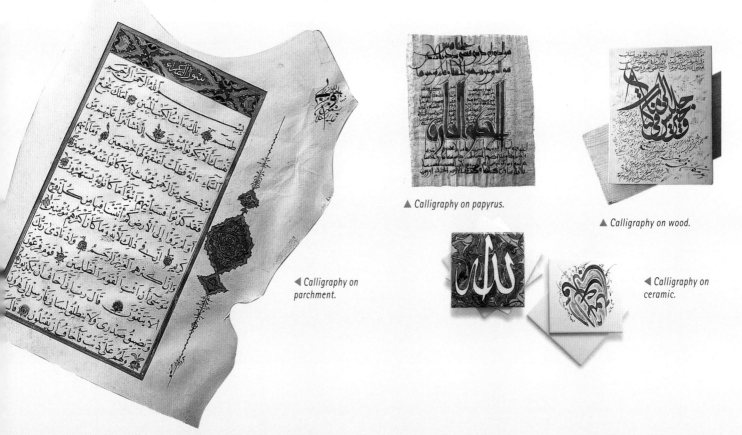

▲ Calligraphy on papyrus.

▲ Calligraphy on wood.

◄ Calligraphy on parchment.

◄ Calligraphy on ceramic.

Originating in China, the technique of making paper from scraps of linen or hemp was introduced into the Muslim world by Chinese prisoners of war who were brought to Baghdad via Samarkand in 751.

Paper was strong competition with Egyptian papyrus. Its appearance played an important role in the softening of calligraphy's letters and in the creation of new cursive styles. It modified the use of angular forms, which became the favorite style of writing for decorating monuments (whether on wood, ceramic, mosaic, stone, or on stucco), as opposed to cursive writing essentially used on paper.

The ancient calligraphy masters made their own papers, and colored and coated them using natural products, like walnut or pomegranate bark, flour, and egg. Even today, calligraphers color and coat paper to get many results, like relief effects or "ageing."

As a beginner, you need to work on a suitable basic paper. You want to avoid papers that are too porous, which drink in the ink without letting the written gestures show through. Likewise, avoid papers that are too glossy; they cause the ink to "shrivel" on their surfaces, which is not good for a learner.

A calligrapher is always actively involved in choosing his or her materials, and in using them. However, calligraphers must respect these rules:
■ Cut the qalam correctly.
■ Use paper that allows for harmony between the qalam and the paper (neither too porous nor too glossy).
■ When dipping the qalam, anticipate and choose the correct take-up amount of ink.
■ Make sure that the nib is sculpted in accordance with the movement and form of the calligraphy being created.
■ Preserve the qalam's "personality" (by holding it at a correct angle and position).

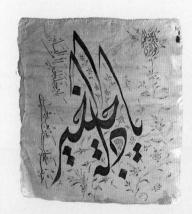

◀ Calligraphy on dried leaf.

▶ Calligraphy on bone.

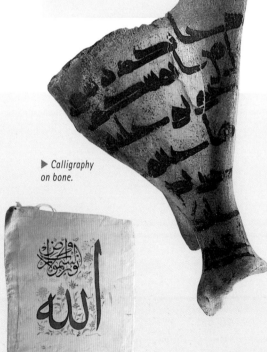

◀ Calligraphy on bronze medals.

▲ Calligraphy on silk.

BASIC SCRIPT TECHNIQUES

Your position

First of all, find the best position for your body: leaning slightly forward without support, or leaning against your chair back, or pressing up against the table. The table surface and the chair should be stable and have a difference in height to allow you to rest your elbows comfortably on the table, for ease of motion. Your feet should be flat on the floor, or resting on a low footstool. Sometimes, when creating large letters, you'll be working standing up.

It's best to place the paper on a slightly inclined cardboard support surface, to get a better overall view of your work. (You'll notice that the inclination of the letters is the same as that of the cardboard.) For the ideal lighting conditions the light should come from your right, since Arabic script is written from right to left.

▼ *"Beautiful" calligraphy is composed of a correct line. A correct line is achieved by a correct movement, which is only possible if the posture is correct.*

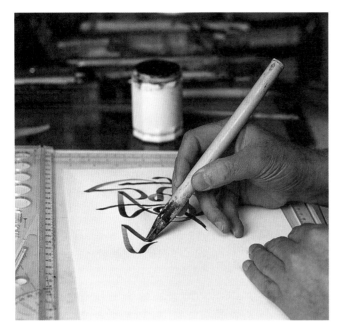

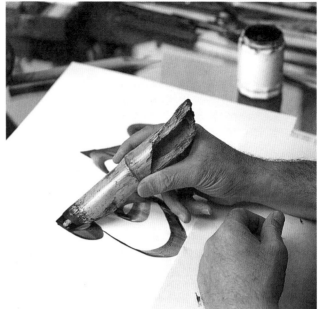

Holding the qalam

The qalam is held with three fingers: the thumb, the index finger, and the middle finger. The thumb turns the pen toward the right, the index finger turns it toward the left, and the pen rests on the middle finger. The two other fingers more or less rest on the paper, according to the shape of the letter. In this position, your hand could be compared to a compass—the instrument for drawing circles and arcs—with one part of your hand holding the pen, and the other pivoting it.

The free hand is placed on the supporting surface and plays a complementary role to the other. They are like "two sisters," according to an Arabic proverb.

To avoid stray marks, use a piece of blotting paper placed under the hand that's in contact with the paper.

To get a good line, you just need to hold the pen without squeezing it too tightly, so that it becomes a natural extension of your hand. Spend time finding the right pressure; if you use pressure that's too strong, it will widen the split in the nib, which will make a thicker line than the one you planned and will stop the ink from flowing properly. Always keep in mind that the quality of your action is more important than the quantity. Otherwise, a tired, indifferent, or mechanically-moving hand will reject the qalam, which will then "take the initiative."

Ancient calligraphers said that the qalam is like "the hand's tongue." If you use a qalam you must respect it, just as a rider respects his horse. Otherwise, if it is badly treated or constrained, it will rebel.

Inking the qalam

It is important to take up only the correct quantity of ink needed for a "journey." By that, we mean the line composed of a downstroke, an upstroke, and an intermediary stroke.

Between each take up of ink, we pause, which we call the letter's articulation. This pause is required, not only to recharge the ink, but also to think, which gives the script its contemplative dimension. It's easy to see why the continuous lines made by bevel-headed felt-tips or pens with an ink reservoir will never replace the lines made by a qalam with its one-of-a-kind results.

YOUR FIRST LINES WITH THE QALAM

As with all artistic disciplines, apprenticeship in calligraphy starts with repeating graphic exercises, while respecting certain fundamental principles.

Perfecting the form

■ Give each letter its necessary portion of lines:

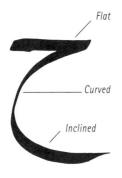

■ Perfect the shape, taking its entire measure into account, as being out of proportion on one side will cause disproportion on the other side:

■ Give the letter the allure in which it will manifest itself:

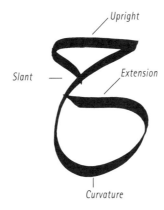

■ For each part of the letter, use the correct side of the qalam: downstroke, upstroke, downstroke, upstroke . . .

Thus, as the line is traced from right to left, you should lean the qalam toward its back (the letter Ba for example); when the line is traced from left to right, you should lean the qalam toward its belly (the letter Jim for example).

■ Take the necessary time for each movement: slow, fast . . .

The correct position of the letter

▲ *From right to left: the letters Jim and Sad.*

■ Link: You arrange linked letters the same way you would pave the ground with flagstones, or slip pearls onto a string.

▲ *Connected letters Dal and Ra.*

■ Compose: This is a question of juxtaposing each separate letter near another, as well and as tastefully as possible.

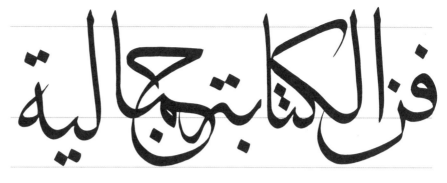

▲ *A dot, unit of measure.*

■ Align: This is done as you add word after word to compose a line, following the line drawn in pencil with a ruler.

▲ *The letter Sin, with final portion extended.*

■ Extend: You stretch the line as if you were firing an arrow, to prolong a letter or a word by giving the impression that it slips out of the pen. This extending action should be done surely and without hesitation.

The proportion between letters

■ The Alif is at the same time a letter and a reference for the other letters. For example:

The letter Dal is composed of the three parts that make up an Alif.

In the same way, the letter Ba is composed of three parts (vertical, horizontal, and curve) that also form an Alif.

It's the same for the other letters. This connection in their proportions assures a harmony among the letters.

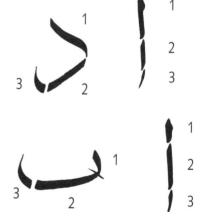

■ The letters that are composed of curved lines must relate to a circle whose diameter is the Alif. You can therefore group the letters by category, according to their place in that Alif-defined reference circle.

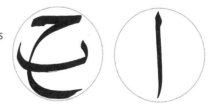

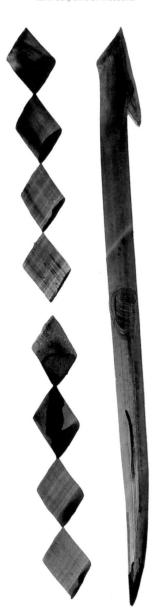

▲ *Alif is composed of eight dots.*

23

FROM A DOT . . . TO A LINE

Very simple at the beginning, Arabic script became an "art" beginning in the first years of Islam in the seventh century. Not only Arabic manuscripts but also Arabic architectural decoration spread throughout the Islamic countries, from Palmyra to Grenada. Often, the receiving countries marked their own cultural influence on the forms and colors.

So with Arabic calligraphy there exists, besides the literal reading, a "visual" reading that comes from the script being enriched by the different cultures it crosses. This diversity, drawn together into a whole, turns into a spirit of unity. The word we translate as "calligraphy," *khatt*, has a completely different definition in daily Arabic, where it means "line." This gives us a sense of the deep dimensions of calligraphy: a composition relating to a line, and where reading the letters resembles reading the lines on a face.

The dot

The dot plays a primordial role both in writing (identifying the letters) and in calligraphy. It gives the shape and the measure of the letters. As a matter of fact, it is the letters' unit of measure (except for Kufic), according with rules established by theorists following the "Perfect Proportion" notion.[2]

From the blackness of the ink that draws this primordial dot the light surges, and the spirit takes flight. Muslim mystics, notably the tenth century Sufis Ibn'Arabi and Al-Hallaj, have spoken long and loud about the dot, seeing it as the face of the Divine. According to Al-Hallaj, the dot is the origin of everything. Even today, the dot is honored by some graphic artists and painters; Wassily Kandinsky wrote a book about it.

1. The words "dot" and "drop of water" are the same word in Arabic.
2. This theory and its applications, established in the ninth and tenth centuries in the School of Baghdad, dominated the golden age of Arabic civilization.

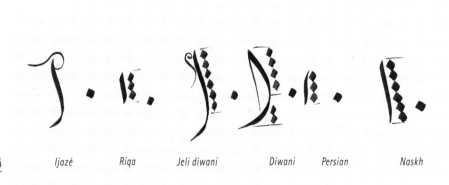

Ijazé Riqa Jeli diwani Diwani Persian Naskh Thuluth

A dot for each style

The form and the size of the dot vary according to the style of script. The dot is slightly inclined (between 25 and 50 degrees), more or less "diamond shaped," or more or less rounded (notably in the Maghrebi style).

The line مشق

The line signifies three things. First of all, the word *khatt* ("line") signifies "the art of calligraphy" to Arabic speakers. Also, the line plays a role in all the dimensions that make up a letter. For instance, according to the percentage of straight lines and curved lines, we call a script either angular or round. Finally, there is the line that we can translate as being the "staff," a guide for alignment and upon which the letters are placed. This line is divided into three levels: an upper line where all the vertical letters begin, a lower line where all the complementary parts finish, and a third line which is variable depending on the style of calligraphy.

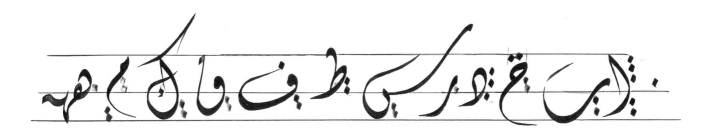

The calligrapher is a draftsperson, even a geometer, in the angular form. The script is integrated into architecture. Sometimes these two arts become entangled and calligraphy, through its role as a means of transcription or decoration, becomes an integral part of architecture. Flexible script, which adheres closely to the hand's movements, benefited from the introduction of paper. We learned to sculpt and bevel the qalam like a science, inclining it to the hand's movement and to the chosen style of script.

If Victor Hugo could write "the cathedral is a gospel of stone," we can say that, in calligraphy, words sculpt architectural space to create a sacred space. In this way calligraphy is similar to other means of expression such as music or poetry. The interaction between the various arts is clearly visible in certain expressions. For instance, in the round form, the word "*Machq,*" used in poetry to describe a slender silhouette, also applies to a well proportioned letter. From these exchanges the idea of unity in diversity was born, and from this the notion of "perfect proportion" was elaborated: that we err by excess or by default, that we miss the just measure. It is from this idea of the respect for "unity in diversity" that schools created different styles (schools of Kufic, Abbasid, Andalusia-Maghreb, Turkish, and Persian), while others improved these forms (schools of Fatimid and Mamluk) by leaving the imprint of their specificity.

"The dot is the principle of any line and the entire line is nothing but united dots. Therefore the line cannot exist without the dot nor the dot without the line. Any line, straight or curved, comes from the movement of this same dot. And everything that falls under the eye is a point between two dots."

Al-Hallaj

▲ *The dot (1) becomes the line (2). The line becomes the letter (3), which becomes a word (4). The word leads to a sentence (5). And the sentence leads to the composition that makes up the work (6).*

Exercises: lines

Drawing the "head" of the letter

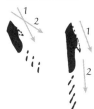

▼ *Two movements for practicing the beginning of curved letters such as Dal.*

Practice the various curves that can make up a letter. The arrows show a motion, or a rotation of the pen (the end of the movement is shown with hatchmarks). Rotating the pen allows you to form downstrokes or upstrokes.

▼ *Back and forth movements to draw the beginning of vertical letters.*

Drawing the "body" of the letter

Drawing the "flourish" (the end) of the letter

Main movements for making the final upstroke.

Movements (upward and downward)

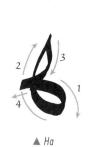

▲ *Ha* ▲ *Ha* ▲ *Kaf* ▲ *Dal* ▲ *Dal* ▲ *Lam* ▲ *Alif*

Living geometry

There are no straight lines in calligraphy done with a qalam, except in Kufic style where they're made with a ruler or a compass.

Calligraphy remains a natural movement: "It transforms spiritual geometry into a dance with the hand whose lines constitute, in a way, the partition," wrote Gérard Blanchard.

In the Thuluth script, considered today a form of perfect calligraphy, the head of Alif has a forehead and a neck, while the body contains a chest, a navel, a hip, a kneecap and a foot . . .

The letter is also broken down into sections, which have these attributes: standing, lying down, stretched out, slanting, and curved.

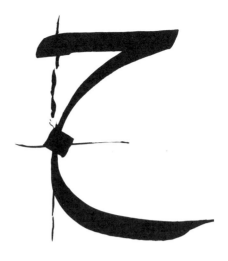

▲ The curved or "rounded" line has only one point of contact with its tangent. One example is the curve in Jim.

▲ The straight line: vertical, horizontal, or slanted.

▲ The circle or portions of a circle: half-circle, quarter-circle, arc of a circle.

▲ The ellipse or portion of an ellipse.

Forehead

Neck

Head

Chest

Navel

Back

Kneecap

Foot

▲ The vertical or "upright" line, as in Alif above.

Studying the lines

Lines can be analyzed as integral parts of the letter, without requiring exact geometrical analysis.

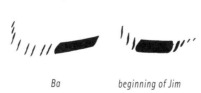

Ba beginning of Jim

▲ The horizontal or "level" line, more or less convex, is the line drawn from right to left, or from left to right as in Ba and the beginning of Jim.

▲ The broken or "bent" line, as in Dal for example.

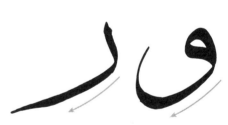

▲ The slanted line, written from right to left, such as Ra or Wau . . .

▲ The triangle: equilateral, isosceles, or right.

▲ . . . Or from left to right as in Ya.

27

Full of imagery

These different lines can be broken down among themselves to form natural figures described by tradition.

For example, a properly drawn Alif evokes the silhouette of a well-proportioned standing person, its head representing one-eighth of the body length. Triangular contours, in certain letters, evoke a pear, while in others the empty spaces take on the aspect of an almond or a seed.

The letter drawn as an image falls between the geometric and the figurative, which allows us to attribute to these images names taken from the animal or vegetable world. This link between the letter and the body is so true that Western typographers use the word "body" to talk about the size of a letter.

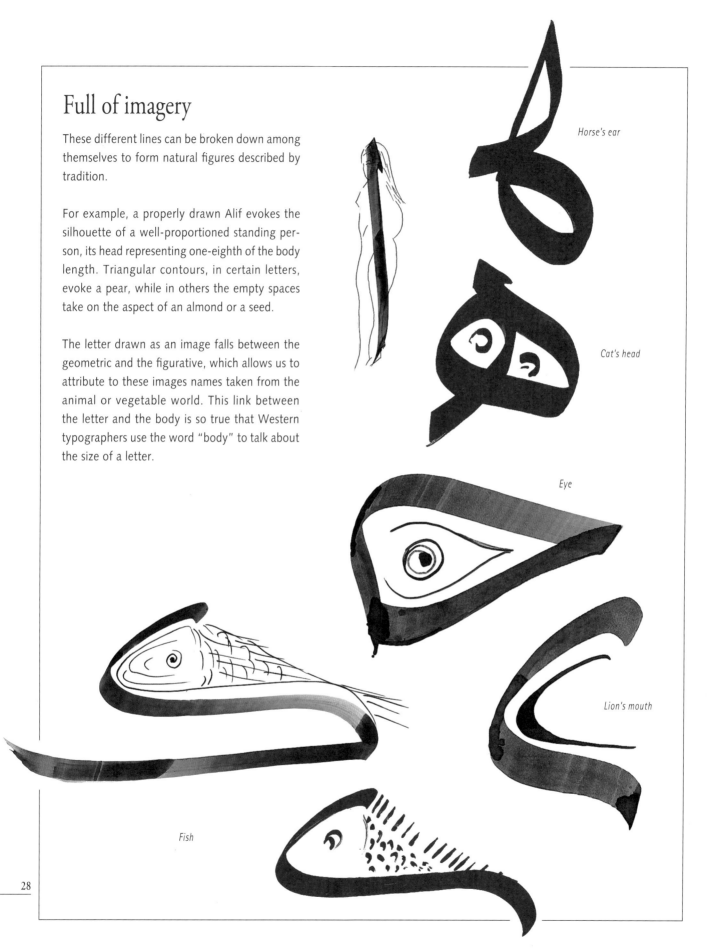

Horse's ear

Cat's head

Eye

Lion's mouth

Fish

Studying the forms

All these forms-letters, symbols of the Arabic language and nation, have become alphabets of movement, gestural alphabets . . .

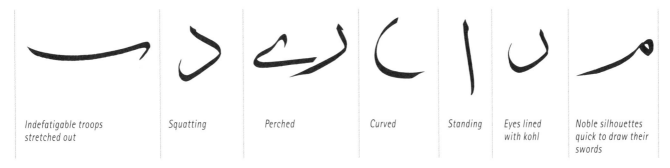

| Indefatigable troops stretched out | Squatting | Perched | Curved | Standing | Eyes lined with kohl | Noble silhouettes quick to draw their swords |

The strokes can dash like acrobats, show teeth, and fire.

The movement of the letters is comparable to that of the shuttle of a weaver who's working on an upright loom. The word *Khatt,* the line, gave birth to the word "thread." The horizontal lines or threads are joined thanks to columns representing the warp in weaving; these repetitive columns are like the succession of days, months, and years. They are time, ever present—the moment—while the horizontal weft lines represent long-term action.

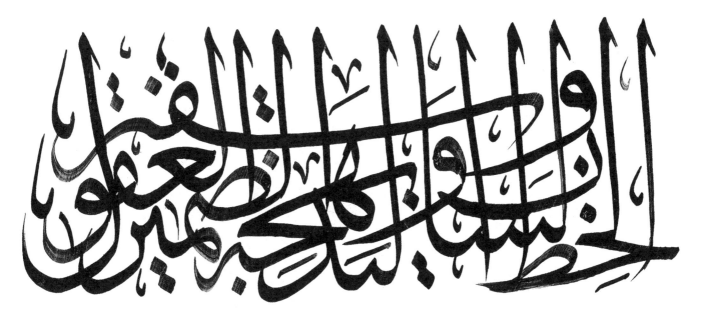

▲ *"Calligraphy is the language of the hand, the pleasure of the spirit, and the ambassador of reason."*

How the letters relate to the qalam

Each letter should be started with the pen's two teeth, called the "full." The movement can be limited to a simple translation or can be accompanied by flexions and rotations. There can also be flexions and rotations of the axis without movement.

For a line drawn from right to left, the pen's head should be slightly turned toward the left, and inversely, for a line drawn from left to right, slightly turned toward the right.

▲ *The qalam's movements at each step of drawing the letter Fa. The nib's position is shown here by guide marks. Remember the direction of writing: from right to left.*

▼ *Breakdown of the qalam's movements for drawing the letter Ta. Remember the direction of writing: from right to left.*

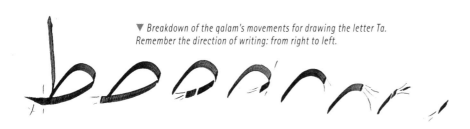

■ The letter's flourish should be drawn with the qalam's top tooth, while a dot should be drawn with both teeth.

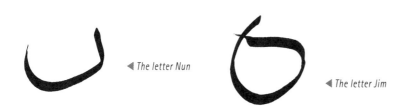

◄ *The letter Nun*

◄ *The letter Jim*

■ The hollow, for example in Nun or Jim, should be drawn with the nib. With Nun, the top tooth leads the movement from right to left, while it's the opposite with Jim.

Downstroke or upstroke

The downstroke corresponds to the width of the pen's nib from right to left or left to right, horizontally or vertically, without turning the pen.

▲ *Notice that the vertical downstroke is thinner than the horizontal.*

The upstroke is the thickness of the pen's nib, made in proportion to the downstroke. These two limits are very rare in the round forms (Thuluth, Naskh, Diwani, Persian).

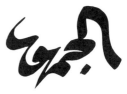

On the other hand, we can see them in forms used in the media, such as Ruq'ah; in free forms; and essentially in Kufic.

In round forms, the meeting point between downstrokes and upstrokes forms the letter. This results in a letter's thickness changing according to the movements.

Vocalization marks and ornamentation

The letters composed on a line leave spaces that are filled by symbols representing short vowels.

These symbols, called vocalization marks or vowel marks, aren't found in the first Arabic script, the Kufic of the first century. They have become necessary, notably in Thuluth, Naskh, and Maghrebi scripts. They are drawn with a smaller qalam, generally one third smaller than the pen used for writing. These vocalization marks aren't used in Persian, Ruq'ah, or Diwani scripts. However, in the Jeli Diwani style the line is elaborately packed with these symbols and dots.

We can also fill these spaces with forms that are purely decorative.

Here, different decorations enrich the meaning of the phrase "Calligraphy is the language of the hand."

◀ *First-century Kufic*

◀ *Thuluth*

◀ *Naskh*

◀ *Jeli Diwani*

◀ *Persian*

◀ *Diwani*

◀ *Riqa*

◀ *Maghrebi*

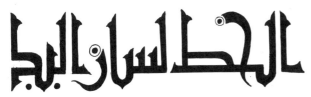

▲ *The sentence forms the base*

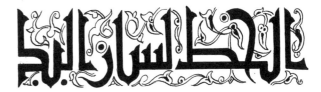

▲ *Plant-based decoration*

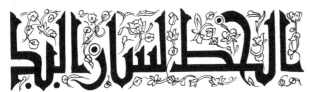

▲ *Floral decoration*

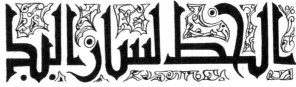

▲ *Abstract decoration*

31

الريحان ◄ *Rayhan*

بسم الله الرحمن الرحيم

المحقق ◄ *Muhaqaq*

بسم الله الرحمن الرحيم

الثلث ◄ *Thuluth*

بسم الله الرحمن الرحيم

النسخ ◄ *Naskh*

بسم الله الرحمن الرحيم

المرسل ◄ *Mursal*

بسم الله الرحمن الرحيم

الرقاع ◄ *Riqa*

بسم الله الرحمن الرحيم

كوفي المصاحف ◄ *Kufic of the Koran*

بسم الله الرحمن الرحيم

كوفي القرن الثاني ه ◄ *Kufic in the second century of Hegira*

بسم الله الرحمن الرحيم

الكوفي الهندسي ◄ *Geometric Kufic*

"In the name of God, full of mercy, the Merciful."

THE STYLES

With the expanse of the geographic area of the Muslim world where numerous people use Arabic script, from Andalusia to India, and with its duration in time—fifteen centuries—it's no surprise that calligraphy has known innumerable forms. Even so, they are classified in two large families: angular (which is written in a geometric form) and round, called "cursive" (which is written in a circle, as part of a circle, or an ellipse).

However, you shouldn't take this too literally, because the angular form has curves; and in the cursive style, certain letters seem straight at a first glance.

The two forms of script came into existence at the beginning of the Nabatean epoch. During the following centuries, and in the places they passed through, they gave birth to numerous styles. However, in this book we are only going to study the six main forms in depth, those which are the matrix of the others: Kufic, Thuluth, Naskh, Diwani and Ruq'ah, Persian, and the Andalusia-Maghrebi.

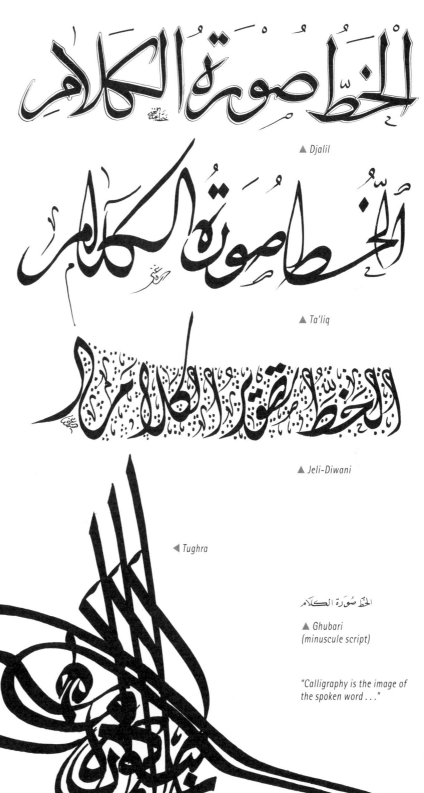

▲ *Djalil*

▲ *Ta'liq*

▲ *Jeli-Diwani*

◀ *Tughra*

▲ *Ghubari*
(minuscule script)

"Calligraphy is the image of the spoken word . . ."

33

KUFIC SCRIPT

Kufic takes its name from the Iraqi city of Kufa. This city was built around the year of Hegira 16 (638 CE) by the second caliph Omar, who made it the political and cultural capital. Mecca, thus freed from political quarrels, consolidated its position as the religious capital. At the same time that Kufa's graphic structures were defined, Abou El Assouad El Doual'Li fixed the grammatical rules concerning the script in the Koran. The Kufic layout benefited from his influence; for example, he decreed the use of the final dot, and the system of vocalization marks—colored dots placed either above or below the letters.

Kufic took its definitive form a little later, when the colored vocalization marks were replaced by signs resembling letters. Thanks to the school of Kufa, this form of angular script matured and the letters took on a certain nobility. As it slowly spread from Andalusia to parts of China, a multitude of variants appeared. So it's not surprising to come across Kufic's name in other styles, like Andalusia-Kufic, Mamluk-Kufic, or Fatimid-Kufic. Among the many styles, we will study the best known: the Kufic of the Koran and floral Kufic.

Considered to be the first attempt, in Arabic script, at calligraphy, Kufic persisted—and its influence continues even today. This style has influenced modern graphic procedures: printing, serigraphy, and even telematics . . . it defies time by imposing itself into modern creations.

◀ "Game of Mirrors." The same phrase ("The kingdom of the earth and the skies belongs to God") is repeated sixteen times to create a geometric composition.

Exercise: form the letters of the alphabet

To make this angular script easier to learn, draw guide marks with a ruler, since each letter is formed at a 90° angle.

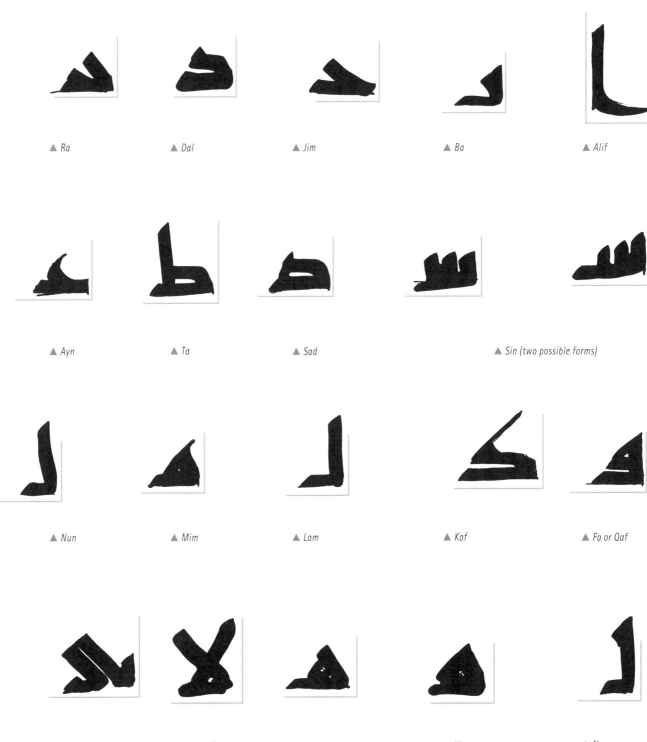

▲ Ra ▲ Dal ▲ Jim ▲ Ba ▲ Alif

▲ Ayn ▲ Ta ▲ Sad ▲ Sin (two possible forms)

▲ Nun ▲ Mim ▲ Lam ▲ Kaf ▲ Fa or Qaf

▲ Ya ▲ Lam-Alif ▲ Ha ▲ Wau ▲ Nun

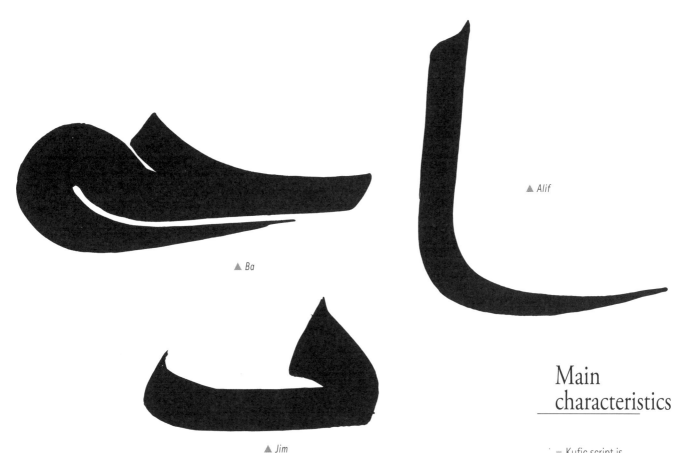

▲ Alif

▲ Ba

▲ Jim

▲ Alif, Ba, and Jim in the Kufic style of the Koran. The isolated letters traced with a qalam show some roundness. On the other hand, the quality of the letters is very different when they are traced with a ruler, as in the example below.

Main characteristics

■ Kufic script is distinguished by its square look; each letter can be drawn within a right angle. However, this doesn't mean the letters are rigid, because certain parts of them are slightly curved.

■ Geometric Kufic is drawn using a ruler, with a drawing pen and a paintbrush, as in any geometric design (the qalam is only used in the Koran form).

■ This style doesn't follow strict composition rules: it can be richly and freely decorated.

▲ "Calligraphy is the image of the spoken word" in Kufic of the first and second centuries of Hegira. We can clearly see the medial line upon which the linked letters are posed.

Kufic of the Koran

During the first centuries of Islam, this particular Kufic was drawn with a qalam, without flourishes or vocalization marks, and even without punctuation. With the creation of vocalization marks, colors started to be used (red, yellow, and green) that symbolized punctuation marks. Then, in the third century of Hegira, downstrokes and upstrokes began to appear.

Even after the appearance of round forms, Kufic continued to be used to transcribe the Koran, probably to carry on the prophetical tradition.

▲ Kufic before and during the first century of Hegira.

▲ Alif

Exercise on three letters in the Kufic of the third century of Hegira (seventh century CE).

Notice the appearance of upstrokes and downstrokes.

▲ Kufic during the second century of Hegira: the appearance of vocalization marks.

▲ Ba

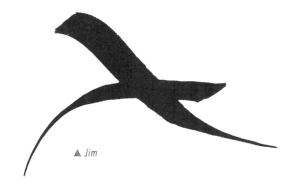

▲ Jim

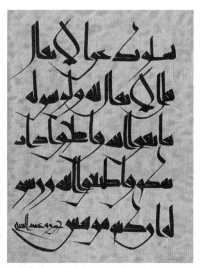

▲ Kufic in the third century of Hegira.

Flowery or leafy Kufic

▲ *The written form of the alphabet serves as a base (top) for a composition where decorative elements integrate the empty spaces (bottom).*

This style was developed during the reign of the Fatimids in Egypt and, at the same time, in Syria-Mesopotamia and in the northwest of what is now Iran. It is found in the decoration of both religious and secular monuments (mosques, palaces, mausoleums). It appeared mainly in applied arts (pottery, ceramic, armories . . .). The floral patterns were added to the top or the tail of the final letters of a word. Often the floral decorations occupied the entire width of the band used for the inscription.

Floral Kufic was used in the mosque in Cairo until the sixteenth century. Today, it is also used in painting. The letters are more "drawn" than calligraphed, because qalams aren't used in their creation.

Square Kufic

This form is also called *shutranji,* meaning "chessboard." It was developed in Iran and central Asia. The unit composing the letter is the square, which is repeated, and which preserves a balance between the form and the essence. This script is produced rather like a maze.

This geometric quality has allowed it to occupy a major place within Muslim architecture, notably in mosques in Asia Minor and Iran.

Today, the freedom offered by square Kufic allows contemporary artists to combine a play of light with color, creating original artwork, such as certain works by Vasarely. This form is considered drawing, and is first created on graph paper, then finished using a drawing pen. No qalam is used.

▲ *Kufic adapts to modern uses, including architectural presentations.*

39

هل الكفر الا ان ترى الحق ظاهرا

فتضرب للانظار من دونه ستر ا

وان تبصر الاشياء بيضاء نورها الصعا

فتظهر ها لناظر قانية حمر ا

اذا كان في عرى الحس قبح جا

فاحسن شي في الحقيقة ان يعرى

فيلمسها من مارست عينه عمى

ويبصرها من كان في اذنه وقرا

خط غنى العاني

THULUTH SCRIPT

If the school of Kufa developed square script, the school of Baghdad dedicated itself to cursive script, thanks to three great masters, the pillars of this school: Ibn Muqla, Ibn Bawad, and Yaqut Musta'simi.

Ibn Muqla, a remarkable humanist of the tenth century (he was a politician, three-time vizier, and an expert in the humanities and geometry), profited from both his own personal experience and from those of his time, where the principles of the "Perfect Proportion" had already been created in science and in the arts. He fixed calligraphy's fundamental elements: the dot, the line, the circle. The dot is defined as the starting spark of each line, the germ of each letter, the smallest fraction of time and space, and it personifies the nib of the qalam. From the dot springs the line, a succession of dots where the letters are linked like notes of music on a staff. The circle, where the letter coils up, has a dot for its center and Alif for its diameter.

Ibn Bawab, in the tenth century, was guided by his painter's soul. In each letter he saw movements above all: those that compose it, and those that create the harmony. He fixed the proper proportion of Alif which, when drawn in calligraphy correctly, should evoke a graceful silhouette. He broke it down into eight dots, one of which is the head, equal to one eighth of the body, the same as in a person's anatomy. The letters come to life on the line in a graphic harmony, a choreography that the calligrapher produces.

With Yaqut Musta'simi, in the thirteenth century, calligraphy became painting, reflecting the calligrapher's universe. The epoch was ruled by the principle of the unity of knowledge. Yaqut Musta'simi was a poet, musician, philosopher and calligrapher . . . to him, art and literature were one and the same. The letter became the pretext for purely aesthetic games; poetry took on a form, beautiful to speak, to hear, and to look at.

◀ Modern poem about freedom of expression by Marouf El Rissafi (Iraqi philosopher).

41

Exercise: form the letters of the alphabet

The arrows shown here correspond to a step-by-step movement or rotation of the qalam. The letters aren't written in a single stroke; it's sometimes necessary to lift the qalam to reorient it and finish drawing the letter.

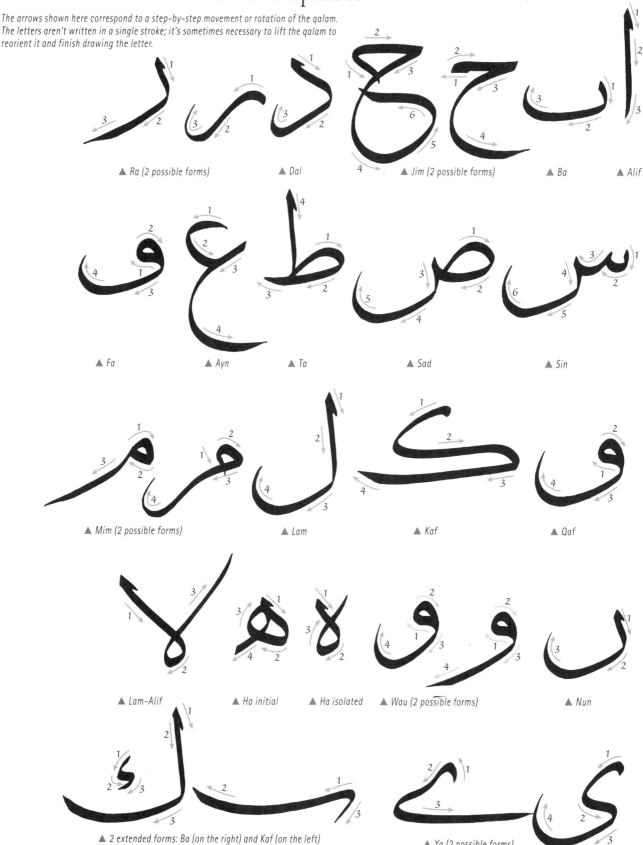

▲ Ra (2 possible forms) ▲ Dal ▲ Jim (2 possible forms) ▲ Ba ▲ Alif

▲ Fa ▲ Ayn ▲ Ta ▲ Sad ▲ Sin

▲ Mim (2 possible forms) ▲ Lam ▲ Kaf ▲ Qaf

▲ Lam-Alif ▲ Ha initial ▲ Ha isolated ▲ Wau (2 possible forms) ▲ Nun

▲ 2 extended forms: Ba (on the right) and Kaf (on the left) ▲ Ya (2 possible forms)

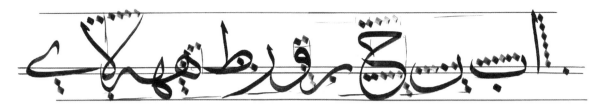

▲ *In Thuluth, the structural line (the staff) presents three levels: upper, lower, and horizontal.*

Thuluth, considered the perfect form of cursive script, is nicknamed "the mother of calligraphy." It is the most complete style, with the richest gestures, and studying it offers the learner a global understanding of script. A proverb asserts that "If you don't know Thuluth, you are not a calligrapher." So it's advised to begin your study by learning it.

Links for Ba (and letters like it)

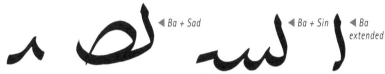

◄ *Ba + Jim* ◄ *Ba* ◄ *Ba + Alif* ◄ *Ba*

Followed by a descending letter, here Jim.

Followed by a letter with a vertical stroke, here Alif: Ba loses its secondary part.

◄ *Ba + Sad* ◄ *Ba + Sin* ◄ *Ba extended*

Placed in the middle of a word, no matter what the following letter is.

Followed by Sad: to create harmony, Ba is enlarged in relation to Sad.

Followed by Sin: since the letters have the same graphic nature, Ba is extended.

Main characteristics

■ The word Thuluth means "a third" in Arabic. In calligraphy all the fractional measures are given based on the pen's nib, and take into account the straight lines in relation to the curved lines.

■ This division by a third is found everywhere. It's in the dot, in the movements, and in the structural line.

■ The three-part repartition is also manifested in the "physiognomy" of the letter, which normally includes a head, a body, and legs. The vocalization mark is drawn with a qalam that is one-third the size of the one used for the script.

Links for Jim (and letters like it)

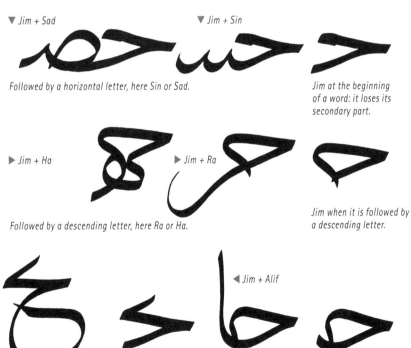

▼ *Jim + Sad* ▼ *Jim + Sin*

Followed by a horizontal letter, here Sin or Sad.

Jim at the beginning of a word: it loses its secondary part.

▶ *Jim + Ha* ▶ *Jim + Ra*

Followed by a descending letter, here Ra or Ha.

Jim when it is followed by a descending letter.

◄ *Jim + Alif*

Jim as a final: it regains its isolated form.

Placed in the middle of a word, no matter what the following letter is.

Jim when it is followed by an ascending letter.

43

Links for Sin (and letters like it)

▼ Sin + Jim

▼ Sin + Sad

Followed by a horizontal or ascending letter: here with Sad.

Followed by a descending letter: here with Jim.

Sin at the beginning of a word: it loses its secondary part.

▼ Sin + Jim

Sin as a final: it regains its isolated form.

Placed in the middle of a word and followed by a descending letter: here with Jim.

Sin when it is placed in the middle of a word.

Links for Sad (and letters like it)

▼ Sad + Ra ▼ Sad + Jim

▼ Sad + Ba

Followed by a descending letter: here Jim or Ra.

Followed by a horizontal letter: here Ba.

Sad at the beginning of a word: it loses its secondary part.

Links for Ta

Ta as a final: it keeps its isolated form.

Whether the following letter is ascending, horizontal, or descending, Ta stays the same.

Ta: No matter where it is placed in a word, it stays the same.

Links for Ayn (and letters like it)

▼ Ayn + Alif ▼ Ayn + Ba

Placed in the middle of a word, its line is completely different.

Followed by an ascending letter: here Alif.

Followed by a horizontal or descending letter: here Ba.

Ayn at the beginning of a word: it loses its secondary part.

Links for Fa (and letters like it)

▼ *Secondary part*

Fa placed in the middle of a word. As a final it loses its secondary part.

▼ *Fa + Sin*

Followed by a horizontal or ascending letter: here Sin.

▼ *Fa + Ra*

Followed by a descending letter: it loses its secondary part.

Fa at the beginning of a word: it loses its secondary part. By adding two dots above it, it becomes Qaf.

Links for Kaf

Kaf as a final: it regains its isolated form.

▼ *Kaf + Alif*

Placed at the beginning of a word and followed by an ascending letter: here Alif.

Placed in the middle of a word and followed by a horizontal or descending letter.

Kaf at the beginning of a word.

Links for Lam

Lam when used for writing the word "Allah."

▼ *Secondary part*

No matter what the following letter is, Lam (in the middle of the word) stays the same. As a final, it loses its secondary part.

▼ *Lam + Mim*

Exceptional form of Lam: when it is linked to Mim, the line goes toward the right instead of toward the left.

▼ *Lam + Sad*

Lam at the beginning of a word and linked to a horizontal letter: here Sad.

Links for Mim

Mim as a final.

Place in the middle of a word and followed by an ascending letter.

Placed in the middle of a word and followed by a horizontal or descending letter.

▼ *Mim + Sad*

Followed by a horizontal or ascending letter, here Sad: it loses its secondary part.

▼ *Mim + Ra*

Mim at the beginning of a word and linked to a descending letter: here Ra.

Links for Ha

Ha as a final: 2 possible forms.

Placed in the middle of a word and no matter what the following letter is: 2 possible forms.

Ha at the beginning of a word.

Thuluth accepts all sorts of geometric compositions: square, round, rectangular, symmetric . . . This style allows for the invention of free forms and can also be used for creating logos. It creates spaces inside the letter, spaces that have contours suggesting the shapes of plants or animals: eyes with a piercing look, almonds, fruits, and more (see page 28).

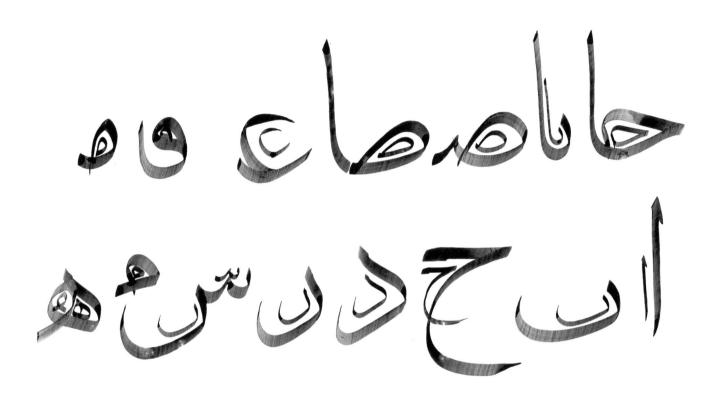

Aside from creating a space in movement, equalizing the composition, and the many decorative patterns used to bring its spaces to life, Thuluth style also includes the vocalization marks to make reading easier.

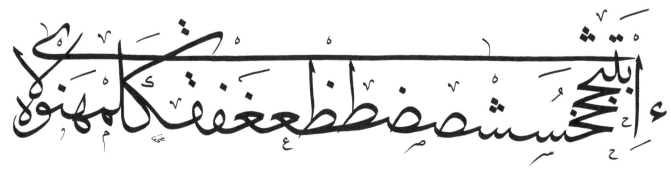

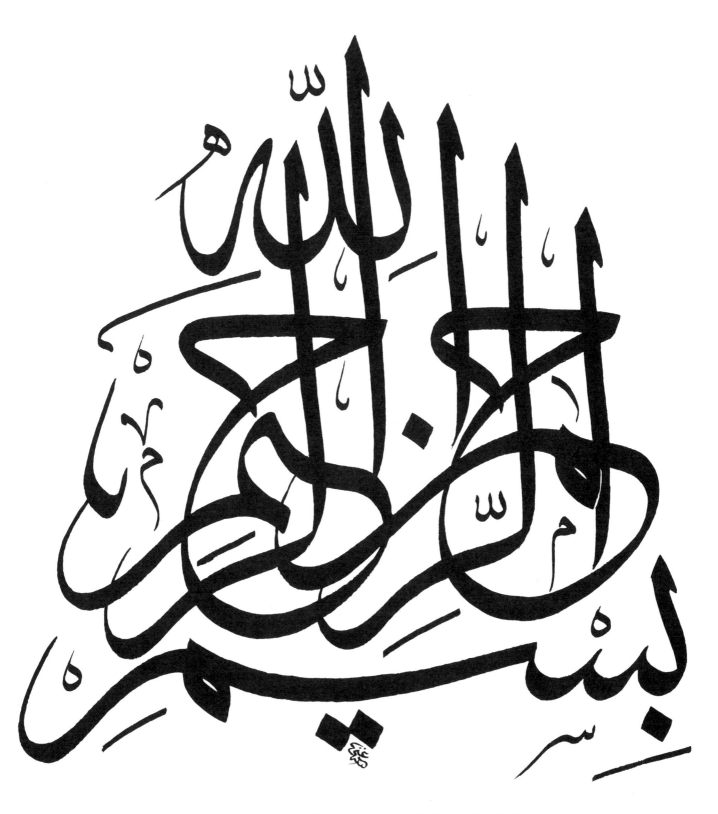

▲ Symmetric work. The elements of the phrase "In the name of God full of mercy, the Merciful" are repeated, and some letters are extended, to create an original graphic composition.

وَالْأُولَىٰ ۞ فَأَنذَرْتُكُمْ نَارًا تَلَظَّىٰ ۞ لَا يَصْلَىٰهَآ إِلَّا الْأَشْقَى

الَّذِى كَذَّبَ وَتَوَلَّىٰ ۞ وَسَيُجَنَّبُهَا الْأَتْقَى ۞ الَّذِى يُؤْتِى

مَالَهُ يَتَزَكَّىٰ ۞ وَمَا لِأَحَدٍ عِندَهُۥ مِن نِّعْمَةٍ تُجْزَىٰٓ ۞ إِلَّا ابْتِغَآءَ

وَجْهِ رَبِّهِ الْأَعْلَىٰ ۞ وَلَسَوْفَ يَرْضَىٰ

بِسْمِ اللَّهِ الرَّحْمَٰنِ الرَّحِيمِ

وَالضُّحَىٰ ۞ وَالَّيْلِ إِذَا سَجَىٰ ۞ مَا وَدَّعَكَ رَبُّكَ وَمَا قَلَىٰ

وَلَلْآخِرَةُ خَيْرٌ لَّكَ مِنَ الْأُولَىٰ ۞ وَلَسَوْفَ يُعْطِيكَ رَبُّكَ فَتَرْضَىٰ

۞ أَلَمْ يَجِدْكَ يَتِيمًا فَـَٔاوَىٰ ۞ وَوَجَدَكَ ضَآلًّا فَهَدَىٰ

وَوَجَدَكَ عَآئِلًا فَأَغْنَىٰ ۞ فَأَمَّا الْيَتِيمَ فَلَا تَقْهَرْ

۞ وَأَمَّا السَّآئِلَ فَلَا تَنْهَرْ ۞ وَأَمَّا بِنِعْمَةِ رَبِّكَ فَحَدِّثْ

بِسْمِ اللَّهِ الرَّحْمَٰنِ الرَّحِيمِ

NASKH SCRIPT

Etymologically, *Naskh* is derived from the verb "to copy." Here it means "beautiful script." It was codified at the beginning of the tenth century by Ibn Muqla and his brother.

This style belongs to the cursive family. Its clarity and legibility make it perfect for use in all manuscripts. In modern times, it has also been adopted by typographers as a block letter for publishing and printing (for instance, it appears on keypads for computers). It's often seen in advertising and publicity materials. So it's a logical script to teach to schoolchildren, and to adults wanting to learn Arabic script.

Naskh, associated with Thuluth, gave birth to an intermediary style: the Ijazé (which can be translated as "allowed"). In a letter in Ijazé, for example, the principal part might be written in Naskh and the secondary part in Thuluth.

◀ *Sura XCIII of the Koran: "Break of Day."*

Exercise: form the letters of the alphabet

The arrows shown here correspond to a step-by-step movement or rotation of the qalam. The letters aren't written in a single stroke; it's sometimes necessary to lift the qalam to reorient it and finish drawing the letter.

▲ Ra (2 possible forms) ▲ Dal ▲ Jim ▲ Ba ▲ Alif

▲ Ayn ▲ Ta ▲ Sad ▲ Sin

▲ Kaf (2 possible forms) ▲ Qaf ▲ Fa

▲ Ya ▲ Lam-Alif ▲ Ha ▲ Wau ▲ Nun ▲ Mim (2 possible forms) ▲ Lam

Links for Ba (and letters like it)

Exceptional forms of Ba.

▼ Ba + Sad

Followed by Sad: Ba is enlarged in respect to Sad.

◄ Ba + Alif

Followed by a letter with a vertical stroke, in this case Alif: Ba loses its secondary part.

▼ Ba isolated

Ba in medial and in final where it regains its secondary part.

Ba in medial and preceded by the same sort of letter, in this case another Ba.

▼ Ba + Jim

Ba in medial preceded by a horizontal letter.

Ba in medial.

Links for Jim (and letters like it)

As a final: it regains its isolated form.

In medial and followed by a rising letter.

At the beginning of a word and followed by a rising letter.

At the beginning of a word and followed by a descending letter.

At the beginning of a word: it loses its secondary part.

Isolated form.

Links for Sin (and Chin, which is similar)

As a final: it regains its isolated form.

In medial and followed by a descending letter.

At the beginning of a word and followed by a descending letter.

At the beginning of a word and followed by a horizontal or ascending letter: it loses its secondary part.

Isolated form.

Links for Sad (and Dhad, which is similar)

In medial and as a final where it regains its isolated form.

In medial no matter what letter follows.

At the beginning of a word and followed by a horizontal or descending letter: it loses its secondary part.

Isolated forms.

Links for Fa and Qaf

As finals: they regain their isolated forms. To look more attractive, their secondary parts can be extended to take up empty space.

▼ Qaf ▼ Fa

In medial no matter what letter follows.

Isolated forms.

Special Links

◄ Lam-Alif ▼ Wau ▲ Ra ▼ Dal ▼ Alif

Letters that link only on one side: the left.

Final forms of Mim.

Main characteristics

■ If Thuluth views the script as being in thirds, Naskh could be defined as viewing it in "halves."

Naskh reflects these relationships: Half for legibility, the other for art; half for straight lines, the other for curves. The vertical letters seem to be drawn with half the qalam, and the horizontal letters drawn with the entire nib.

■ In the line of the script's structure, the horizontal is almost in the center. The upper limit is indicated by vertical strokes and the lower limit by round secondary parts.

■ Another element of the letter, the head, considered a flourish here, is removed or simplified. Certain letters, such as Fa, are open on the inside, while Ayn is closed.

■ To make things clearer, the style doesn't have a composition. Likewise, vocalization marks are only added where necessary for short vowels, and without any decorative elements.

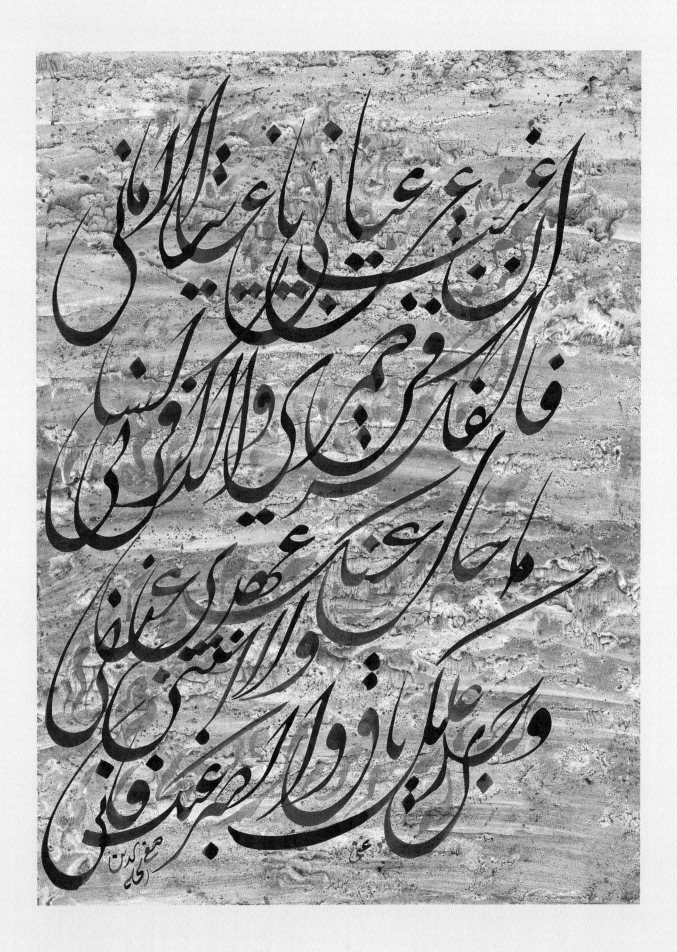

PERSIAN SCRIPT

These scripts were originally created by the Persians from the Ruq'ah, which was a written form used for writing commentaries in the margins of the Koran, to avoid mistaking them for the text itself. The word *ta'liq*, etymologically "commentary," later became a particular style, which became the national Persian script, before being replaced by the Nasta'liq, still in use today. The term *Nasta'liq* is made up of the words *Naskh* (familiar from the previous pages!) and *ta'liq*: we can gather that it is the *ta'liq* used by copyists. It is used for text that accompanies miniature paintings and for transcribing poetry. However, just as Latin-character calligraphy isn't only used by calligraphers to write Latin, the Persian style isn't used only for the Persian language.

Examining the forms of the Nasta'liq alphabet shows that the letters include a principal part close to the Riqa style (see next section), but written with a third of the pen (slit at ⅓ to ⅔), and a secondary part written with the entire pen nib.

According to legend, the style was born through a dream of the calligrapher Mir'Ali of Tabriz, in which Ali, the prophet's son-in-law, asked him to take inspiration from the gait of a goose to forge a new style. The dream proved fertile because, joined to a rich imagination, it resulted in a style that closely followed the caliph's wish. It's interesting to note that the ancient masters advised their students to spend hours contemplating the curves and colors of birds, their gait and their flight, and then to recreate them on their exercise sheets.

◀ *Mystic poem by Safiou El Din El Hili, 1277–1339 (in the year of Hegira 677–752).*

Exercise: form the letters of the alphabet

The arrows shown here correspond to a step-by-step movement or rotation of the qalam. The letters aren't written in a single stroke; it's sometimes necessary to lift the qalam to reorient it and finish drawing the letter.

▲ Dal + Ra
2nd form

▲ Dal + Ra
1st form

▲ Jim

▲ Ba (2 possible forms)

▲ Alif

▲ Ta (2 possible forms)

▲ Sad (2 possible forms)

▲ Sin (3 possible forms)

▲ Mim

▲ Lam

▲ Kaf

▲ Qaf

▲ Fa

▲ Ayn

◀ Ha isolé

▲ Ya (2 possible forms)

▲ Lam-Alif

▲ Wau

▲ Ha: at the beginning (1, 2), in the middle (3, 4), and at the end (5).

▲ Nun (2 possible forms)

Exercises: the links for the letters in Persian style

Links for Ba (and letters like it)

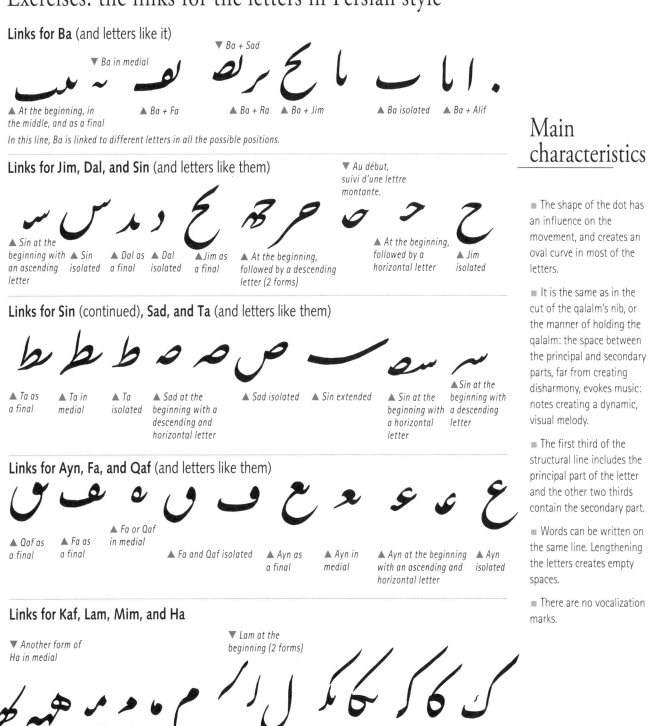

▼ Ba in medial

▼ Ba + Sad

▲ At the beginning, in the middle, and as a final

▲ Ba + Fa

▲ Ba + Ra

▲ Ba + Jim

▲ Ba isolated

▲ Ba + Alif

In this line, Ba is linked to different letters in all the possible positions.

Links for Jim, Dal, and Sin (and letters like them)

▼ Au début, suivi d'une lettre montante.

▲ Sin at the beginning with an ascending letter

▲ Sin isolated

▲ Dal as a final

▲ Dal isolated

▲ Jim as a final

▲ At the beginning, followed by a descending letter (2 forms)

▲ At the beginning, followed by a horizontal letter

▲ Jim isolated

Links for Sin (continued), Sad, and Ta (and letters like them)

▲ Ta as a final

▲ Ta in medial

▲ Ta isolated

▲ Sad at the beginning with a descending and horizontal letter

▲ Sad isolated

▲ Sin extended

▲ Sin at the beginning with a horizontal letter

▲ Sin at the beginning with a descending letter

Links for Ayn, Fa, and Qaf (and letters like them)

▲ Qaf as a final

▲ Fa as a final

▲ Fa or Qaf in medial

▲ Fa and Qaf isolated

▲ Ayn as a final

▲ Ayn in medial

▲ Ayn at the beginning with an ascending and horizontal letter

▲ Ayn isolated

Links for Kaf, Lam, Mim, and Ha

▼ Another form of Ha in medial

▼ Lam at the beginning (2 forms)

▲ Ha at the beginning, in medial, and as a final

▲ Mim at the beginning (3 forms)

▲ Mim isolated

▲ Lam isolated

▲ Kaf in medial with an ascending and horizontal letter

▲ Kaf at the beginning with an ascending and horizontal letter

▲ Kaf isolated

Main characteristics

■ The shape of the dot has an influence on the movement, and creates an oval curve in most of the letters.

■ It is the same as in the cut of the qalalm's nib, or the manner of holding the qalalm: the space between the principal and secondary parts, far from creating disharmony, evokes music: notes creating a dynamic, visual melody.

■ The first third of the structural line includes the principal part of the letter and the other two thirds contain the secondary part.

■ Words can be written on the same line. Lengthening the letters creates empty spaces.

■ There are no vocalization marks.

55

For each letter studied: isolated form, in medial (followed by a horizontal, rising, or descending letter), and as a final if it changes shape.

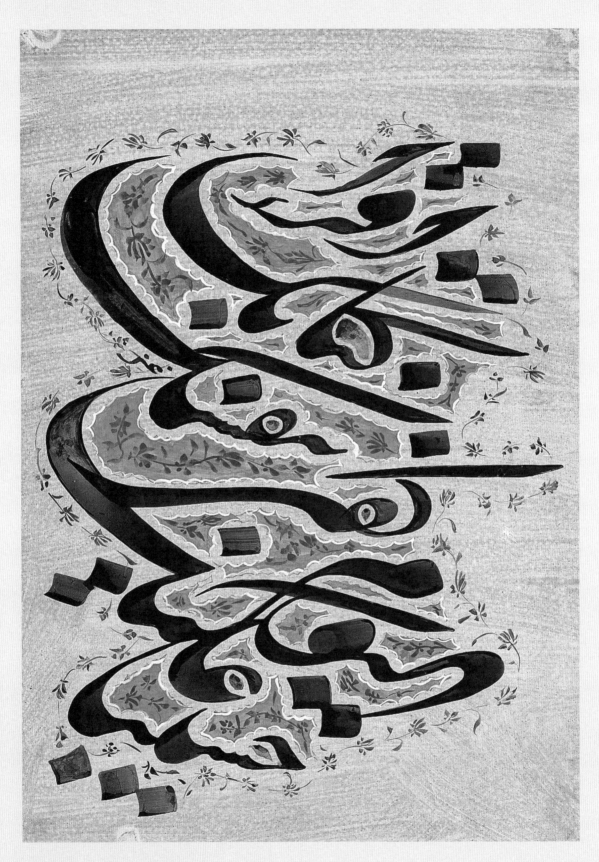

▲ *"Read what you have written; it's all you need for your soul."*

Chekeste or "broken" style

Ta'liq gave birth to another way of using Persian script: Chekeste (which means "broken").

The break referred to here is found in the secondary part of the letter, while the principal part keeps the Nasta'liq form. This break adds a certain rapidity; so Chekeste is used as soon as it's necessary to write quickly and freely; this may happen, for example, in scientific works, but rarely in poetry. But remember, the idea of "breaking" shouldn't be taken too literally: the end of the letter can have some lovely curves.

A good metaphor for this style would be the broken reflection of reeds on the water.

◄ Caption: "He who insists reaches his goal."
Symmetric work in Thuluth, approx. 105 × 105 cm.

57

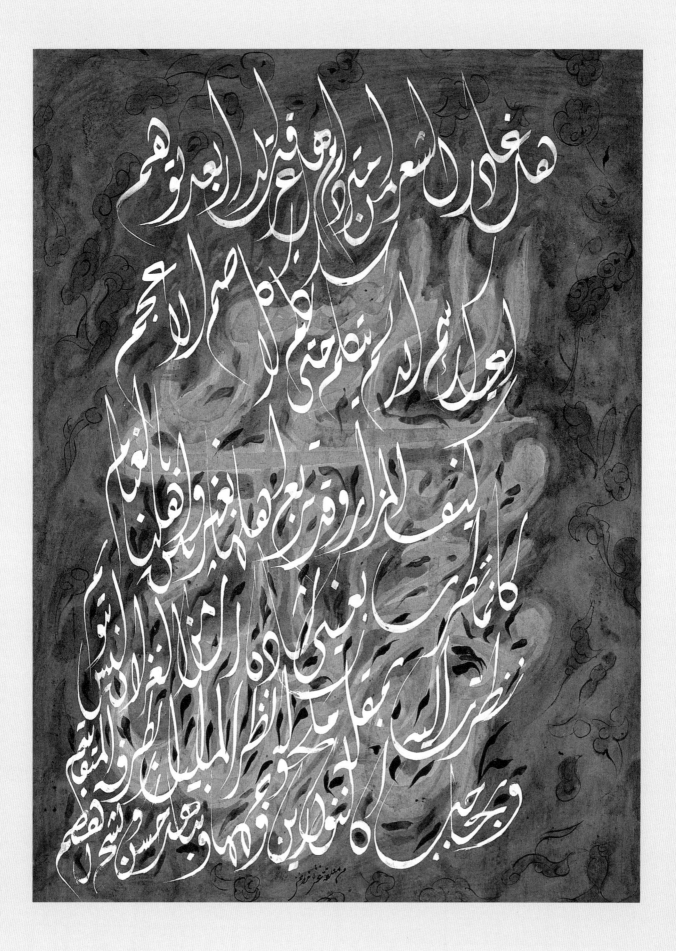

DIWANI SCRIPT

The word *diwani* comes from the verb *dawana*: "attach, write." By extension, the word *diwan* means "reception room," but also means a compilation of poetry. Diwani script also takes on the sense of "government ministry," a purpose that required a specific script, as opposed to religious or scientific scripts.

Reasons of state, especially after the Turks annexed Constantinople in 1453, led to the need for this specificity. The Turks took inspiration from the Persian Ta'liq style, itself influenced by Riqa and Rayhan forms. The beginnings of this style date back to the year of Hegira 857 (1479 CE). Before that time, a coded, hermetic script existed, called Siyakhat ("state channel"). It was reserved for secret governmental affairs.

Generally, in an official document, the text written in Diwani comes after a *Tughra,* a sort of sultan's seal that includes his signature. Diwani was codified by Ibrahim Munif who took inspiration from both Ta'liq and Mosalsal. The influence of the latter, where all the letters are linked together, allowed for very creative word compositions, some of which made for very modern-looking "logos."

Originally created by the Ottomans for ministerial documents, Diwani became a graphic style on the same level as the others, and is one of the principal forms of Arabic script today.

Today it is used as much in poetry as in advertising.

◀ *Beginning of the Mu'allaqat by Antara (pre-Islamic poet, 525–615).*

Exercise: form the letters of the alphabet

The arrows shown here correspond to a step-by-step movement or rotation of the qalam. The letters aren't written in a single stroke; it's sometimes necessary to lift the qalam to reorient it and finish drawing the letter.

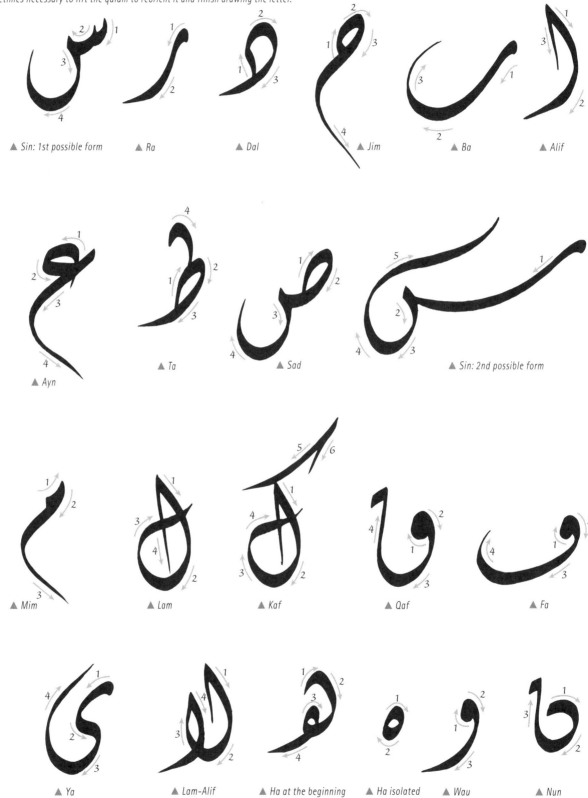

▲ Sin: 1st possible form ▲ Ra ▲ Dal ▲ Jim ▲ Ba ▲ Alif

▲ Ayn ▲ Ta ▲ Sad ▲ Sin: 2nd possible form

▲ Mim ▲ Lam ▲ Kaf ▲ Qaf ▲ Fa

▲ Ya ▲ Lam-Alif ▲ Ha at the beginning ▲ Ha isolated ▲ Wau ▲ Nun

Exercises: the links for the letters in Diwani style

Main characteristics

Links for Ba (and letters like it)

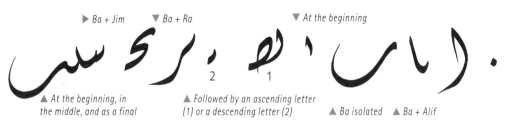

▶ Ba + Jim ▼ Ba + Ra ▼ At the beginning

▲ At the beginning, in the middle, and as a final ▲ Followed by an ascending letter (1) or a descending letter (2) ▲ Ba isolated ▲ Ba + Alif

In this line, Ba is linked to different letters in all the possible positions.

Links for Jim and Sin (and letters like them)

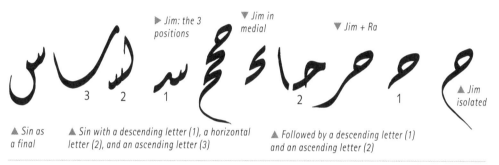

▶ Jim: the 3 positions ▼ Jim in medial ▼ Jim + Ra ▲ Jim isolated

▲ Sin as a final ▲ Sin with a descending letter (1), a horizontal letter (2), and an ascending letter (3) ▲ Followed by a descending letter (1) and an ascending letter (2)

Links for Sad, Ta, and Ayn (and letters like them)

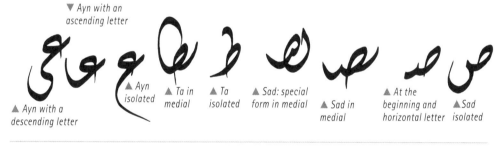

▼ Ayn with an ascending letter

▲ Ayn with a descending letter ▲ Ayn isolated ▲ Ta in medial ▲ Ta isolated ▲ Sad: special form in medial ▲ Sad in medial ▲ At the beginning and horizontal letter ▲ Sad isolated

Links for Ayn (continued), Fa, and Kaf (and letters like them)

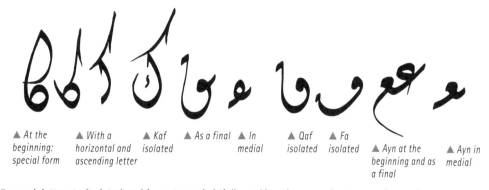

▲ At the beginning: special form ▲ With a horizontal and ascending letter ▲ Kaf isolated ▲ As a final ▲ In medial ▲ Qaf isolated ▲ Fa isolated ▲ Ayn at the beginning and as a final ▲ Ayn in medial

For each letter studied: isolated form, in medial (followed by a horizontal, rising, or descending letter), and as a final if it changes shape.

■ The rules aren't very strict, which allows for greater freedom than in the other styles.

■ The letters offer a wide graphic diversity, creating a backdrop from which the artist can draw without reserve.

■ The dot is thinner than in Naskh; the punctuation has a mix of dots. There are few vocalization marks.

■ The downstrokes, the upstrokes, and their intermediaries have a practically equal value. The lines should be done quickly and surely, which demands great ease in workmanship. (The slightest hesitation alters their shape.) Certain curves are emphasized at their ends, and can even go as far as coiling up into spirals capable of containing one or more words.

■ Besides the fact that their secondary part is removed at the beginning and in the middle of a word, the linked letters don't change very much based on their position.

■ Even though there is neither an upper nor a lower limit, an imaginary line seems to guide the letters, like a staff. In ancient official documents, we can see that the line rises toward the left, creating a perspective effect.

Jeli Diwani

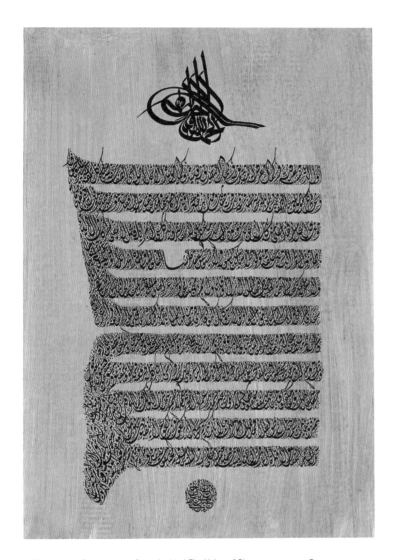

Derived from Diwani, this script is distinguished by its great number of decorative symbols, vocalization marks, and punctuation marks, all drawn with a finer qalam. The word *jeli* means "clear" (even though legibility isn't that obvious here!) and also "great," which shows in the fact that this script quickly attracts the eye.

The whole forms a sort of band, a ribbon whose continuity is broken by vertical extensions (the head of Kaf or tail of Jim), and by one or more openings in the text itself.

By lengthening the secondary parts which only serve a visual reading purpose, we obtain more figurative forms, such as the magnificent boats represented here.

Text written in Jeli Diwani is like the calligrams used by Apollinaire and other poets at the beginning of the twentieth century. It's a matter of arranging the letters and words of a text in a graphic poetic form that communicates its theme.

▲ *Beginning of a text taken from the book* The Voice of Eloquence.

Tughra

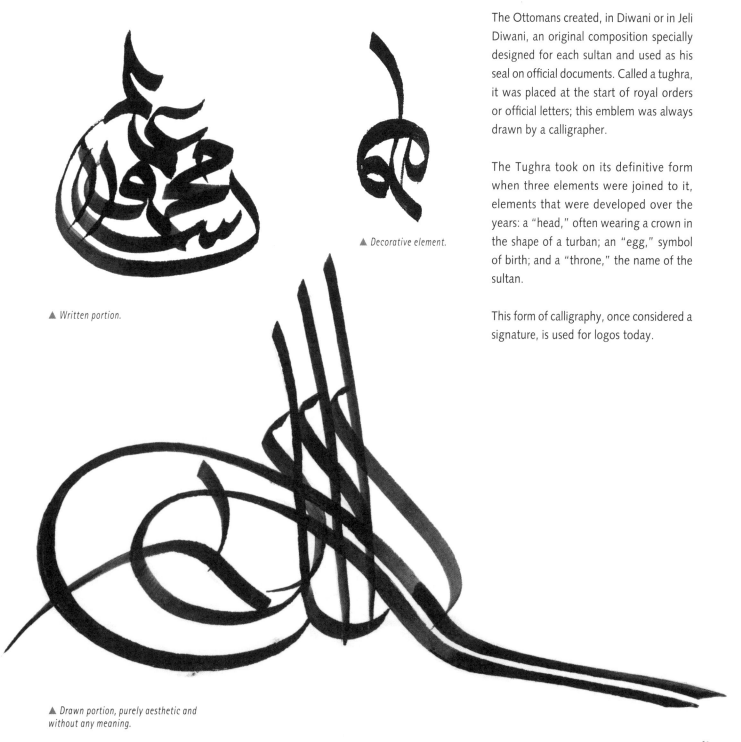

▲ Written portion.

▲ Decorative element.

The Ottomans created, in Diwani or in Jeli Diwani, an original composition specially designed for each sultan and used as his seal on official documents. Called a tughra, it was placed at the start of royal orders or official letters; this emblem was always drawn by a calligrapher.

The Tughra took on its definitive form when three elements were joined to it, elements that were developed over the years: a "head," often wearing a crown in the shape of a turban; an "egg," symbol of birth; and a "throne," the name of the sultan.

This form of calligraphy, once considered a signature, is used for logos today.

▲ Drawn portion, purely aesthetic and without any meaning.

The three elements that make up a Tughra.

القلم اصم

ولكنه يسمع النجوى

واخرس ولكنه

يفصح عن الفحوى

RIQA SCRIPT

Riqa means "piece." (Don't confuse it with Ruq'ah, which is a variety of Thuluth script.) Riqa script was invented by the Turks and is the most recent form of calligraphy. It's perfect for rapid writing.

It was once used in official documents (which explains why the vocal portion of it resembles Diwani, and the decorative part is simplified). It is still largely used in printing, and also for signs, book titles, newspaper headlines, and on demonstrators' billboards! Its clarity answers a basic need for legibility.

Contrary to what you might think, Riqa isn't an easy script. Few calligraphers know its subtleties and its rules, notably the cut of the qalam and how to hold it, which are identical to the cut and position needed for Diwani. In addition, you need a lot of skill to master the speed aspect of the writing.

◀ *"The qalam is mute,*
But it watches the lovers' talk . . .
And deaf,
But it unveils its contents."
—G. Alani

Exercise: form the letters of the alphabet

The arrows shown here correspond to a step-by-step movement or rotation of the qalam. The letters aren't written in a single stroke; it's sometimes necessary to lift the qalam to reorient it and finish drawing the letter.

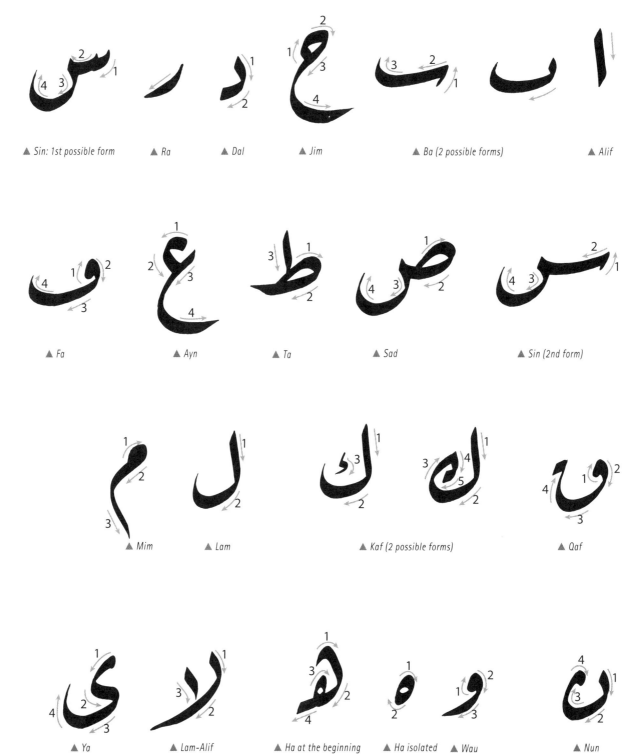

▲ Sin: 1st possible form ▲ Ra ▲ Dal ▲ Jim ▲ Ba (2 possible forms) ▲ Alif

▲ Fa ▲ Ayn ▲ Ta ▲ Sad ▲ Sin (2nd form)

▲ Mim ▲ Lam ▲ Kaf (2 possible forms) ▲ Qaf

▲ Ya ▲ Lam-Alif ▲ Ha at the beginning ▲ Ha isolated ▲ Wau ▲ Nun

Exercises: the links for the letters in Riqa style

Links for Ba (and letters like it)

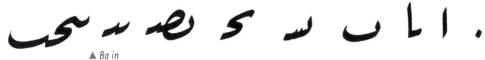

▲ Ba as a final ▲ Ba in medial ▲ Ba + Sad ▲ Ba + Jim ▲ Ba + Sin ▲ Ba isolated ▲ Ba + Alif

In this line, Ba is linked to different letters in all the possible positions.

Main characteristics

- Riqa's layout is about economy of motion: it has neither vocalization marks nor flourishes, and few options for composition. The punctuation dots are sometimes connected to the tail of a letter to speed up writing.

- There are a lot more downstrokes than upstrokes. The transition from downstroke to upstroke and upstroke to downstroke is very short.

- Riqa's dot is equal to half of Naskh's dot.

- The strokes are very short, not only in relation to the value of the dot, but also in terms of the number of dots. For example, Alif only has three dots, but in Naskh it has five.

- Riqa is also distinguished by its regularity; the strokes are equal on each side of the medial line.

Links for Jim and Sin (and letters like them)

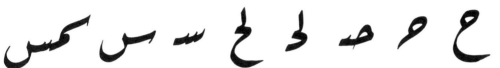

▲ Sin at the beginning and as a final ▲ Sin isolated ▲ Sin at the beginning followed by a horizontal letter ▲ Jim as a final ▲ Jim in medial ▲ At the beginning with a horizontal letter ▲ At the beginning with a descending letter ▲ Jim isolated

Links for Sad, Ta, and Ayn (and letters like them)

▲ Ayn as a final ▲ Ayn in medial ▲ Ayn at the beginning ▲ Ayn isolated ▲ Ta at the beginning ▲ Ta isolated ▲ Sad with a descending letter ▲ Sad with a horizontal letter ▲ Sad isolated

Links for Fa, Qaf, and Kaf (and letters like them)

▲ Kaf in medial ▲ With an ascending and horizontal letter ▲ Kaf isolated ▲ Qaf as a final ▲ Fa as a final ▲ Fa (or Qaf) in medial ▲ With a descending letter ▲ Fa (or Qaf) isolated

For each letter studied: isolated form, in medial (followed by a horizontal, rising, or descending letter), and as a final if it changes shape.

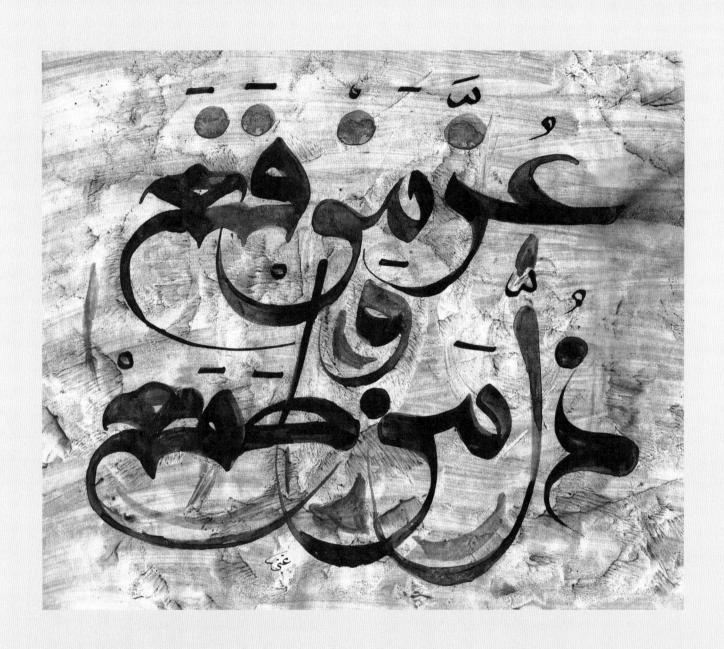

MAGHREBI SCRIPT

As its name suggests, this is the script used in the three Maghreb countries that were influenced by Andalusia. It spread throughout Africa up to the Egyptian borders, and was used to transcribe not only Arabic in Arabic-speaking countries—like Sudan or Mauritania—but also to transcribe languages such as Swahili in Nigeria. This form comes from Kufic, whose influence can be seen in its structure; in its detail, this script is close to the cursive form.

Maghrebi was used in manuscripts as well as in the decoration of palaces and mosques in North Africa and Andalusia. These buildings offer remarkable examples of Maghrebi, with elements such as flowers and foliage; the Alhambra in Grenada, Spain, is one example. The use of colors, such as saffron, green, or red—often typical of African and Maghreb countries—is particularly notable. In sub-Saharan Africa, the influence of first-century Kufic was strong enough to cause the rejection of the cursive form. Magnificent examples of these types of calligraphy can be seen in Timbuktu.

◀ *Andalusia-Maghrebi adage:*
"Prestige for contentment,
humiliation for greed."

69

Exercise: form the letters of the alphabet

The arrows shown here correspond to a step-by-step movement or rotation of the qalam.
The letters aren't written in a single stroke: it's sometimes necessary to lift the qalam to
reorient it and finish drawing the letter.

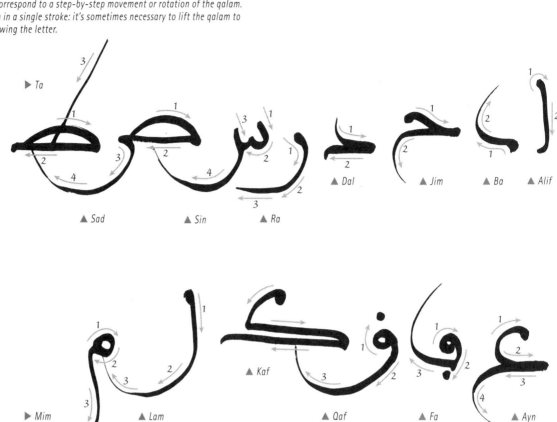

▶ *Ta*

▲ *Dal* ▲ *Jim* ▲ *Ba* ▲ *Alif*

▲ *Sad* ▲ *Sin* ▲ *Ra*

▶ *Mim* ▲ *Lam* ▲ *Kaf* ▲ *Qaf* ▲ *Fa* ▲ *Ayn*

▲ *Ya* ▲ *Lam-Alif* ▲ *Ha* ▲ *Wau* ▲ *Nun*

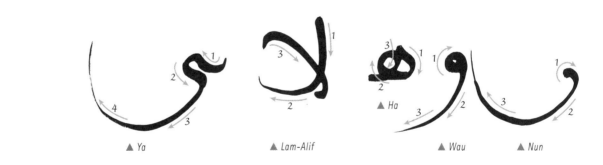

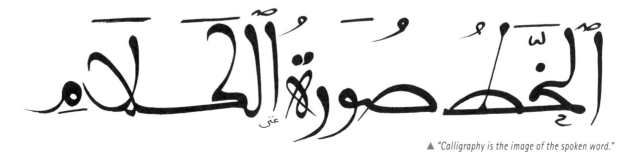

70

▲ *"Calligraphy is the image of the spoken word."*

ابجد هوز حطى

كلم سعفص فرشت ثغذ ضظغا

▲ *The Maghrebi alphabet composed in words, called "abgedi" (alphabet primer)*

Main characteristics

■ This form doesn't have very strict rules. The artist enjoys a great deal of freedom in the formation of the letters, and in the number of options, but it is still clearly distinguished from the formation of letters in Mashriq (an eastern region in the Middle-East).

■ Its curves mostly come from the qalam's preparation (see pages 16 and 17): after the reed is cut in the traditional manner, the tip isn't beveled; the angles are rounded off. Little pith is removed to allow for charging it with ink. As for the slit, it isn't created by slicing the reed, but by digging through the "flesh" to the "bone," thus creating a sort of ink reservoir.

■ The punctuation is different for two letters: Qaf (which is written with the dot over it) and Fa (which is written with the dot under it).

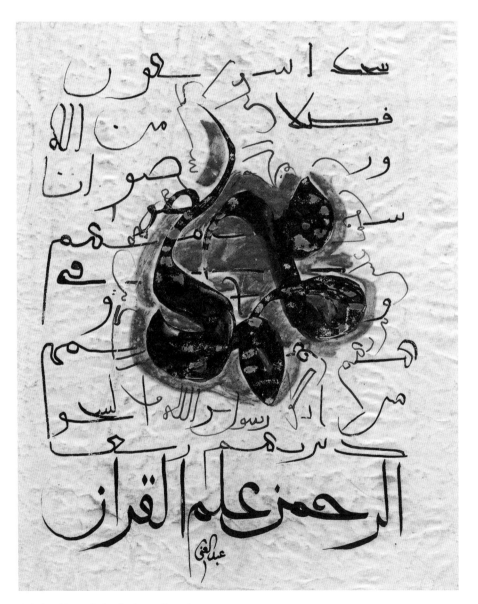

▲ *Isolated form relating the dance of a snake.*

71

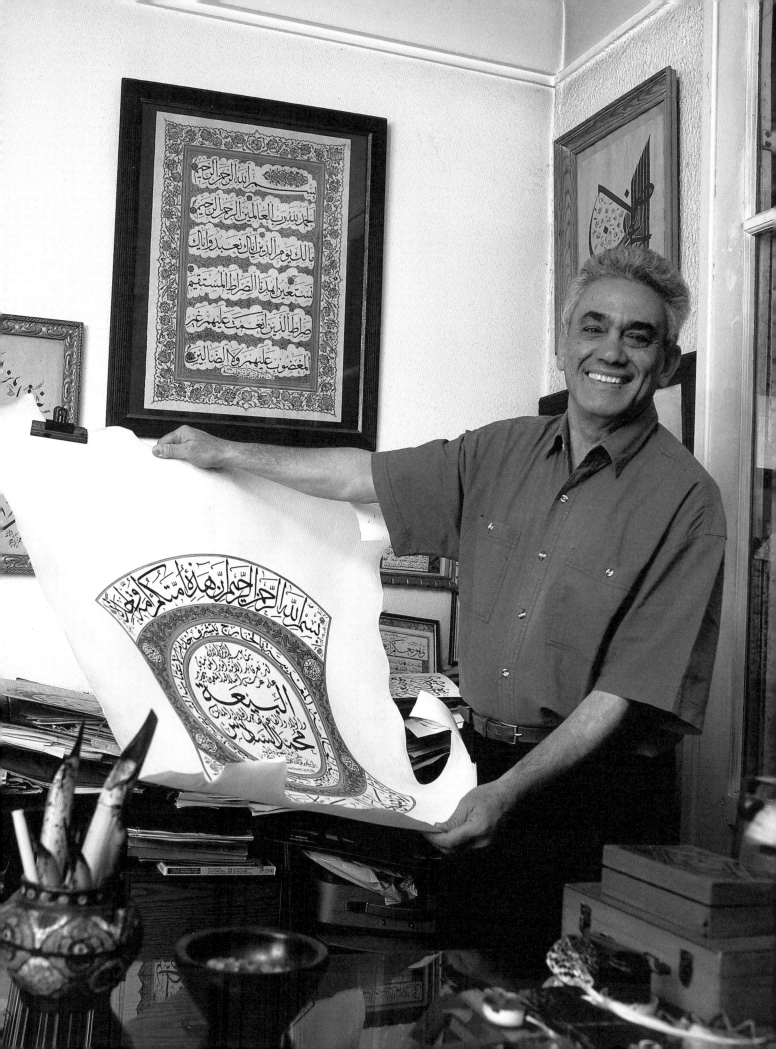

THE FUTURE OF ARABIC CALLIGRAPHY

I have tried here to give you a glimpse of the extraordinary richness of the "art of the line," this art that I have taken upon myself to transmit, just as my master Hashem al-Khattat, better known as El Badadi (1917–1973), taught me. I learned by listening to him, by endlessly repeating the writing exercises, but mostly by watching his every gesture, searching for the correct movement. It is true that a book can't replace a master's teaching and can only be used as a point of reference.

That is what the *Ijazé* concretizes; it is a sort of diploma resulting from an apprentice system like that begun in the Middle Ages. It is a certification of mastery that the master awards only after long years of apprenticeship, and awards to only one of his students. The Ijazé attests to the transmission not of a script, but of the spirit of the letter. It attests that the student draws calligraphy with the spirit described by Abu Hayane el Tawhidi, spokesman for the Brethren of Purity:

"Perfection in the members
Correct proportion in the parts
Acceptance of the soul"

When that moment is reached, the master allows the student to sign his work. The student gives his master a tacit promise to continue on his way, maintaining that which already exists and continuing to develop to assure future prospects.

Calligraphy, thanks to tradition, crosses time and acquires its position as an eternally contemporary art, universal and timeless. Just as the traditional art of typographers in the West continues to live on through telematics—including the technology of sending, receiving, and storing information—the timelessness of Arabic calligraphy is instantly seen by the choice of the most ancient form, Kufic, for computers, without any loss of importance to the cursive form.

If it bends so easily to the constraints of modern technology, it owes that to the very existence of the two very different forms: angular and cursive, which created very early on, as we've seen, technical, scientific, and aesthetic rules.

The art of calligraphy was thus born, and is reborn and shaped by pressures over fifteen centuries; and it hasn't yet exhausted all its resources. Graphic art and other modern forms of communication—television, video—draw their best creations from the revival of the antique Kufic.

My greatest concern since arriving in France over a third of a century ago has been to encourage understanding between people by elaborating a universal language through the magic of calligraphy. Calligraphy, residing beyond the necessity of social communication, becomes a universal language. Whether it is used for scientific or poetic purposes, it transcends them in its search for beauty.

I hope that I have awoken in you, the reader, whether you're Eastern or Western, the desire to take up a qalam and study the traditional art of beautiful script. Far from the tedious writing exercises that have put off so many schoolchildren, calligraphy revives natural movement and the dance of the spirit in everyone. I hope I've brought this "spirit of the letter" to life, by showing you how the art of the line, after its simple beginnings, has known an extraordinary flowering; how it rises in a unique flight from the simple straight "line" or curve toward an image, a flight where the art of the image becomes the image of words.

A GALLERY OF CONTEMPORARY WORKS

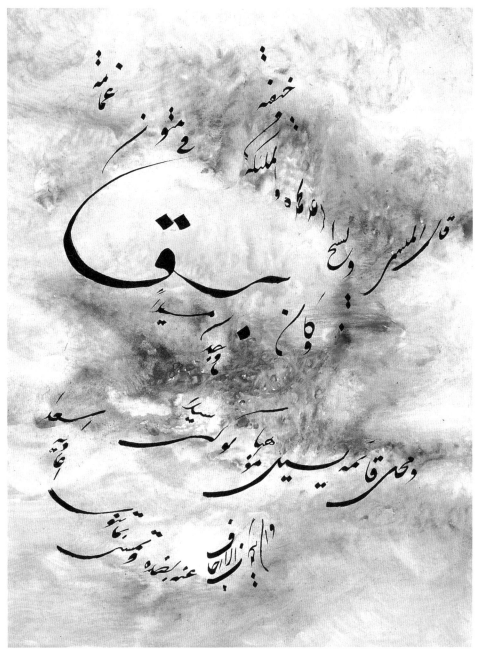

▲ Calligram of a poem evoking the force of nature, by Al-Mutanabbi (914–965 CE). Chekeste style.

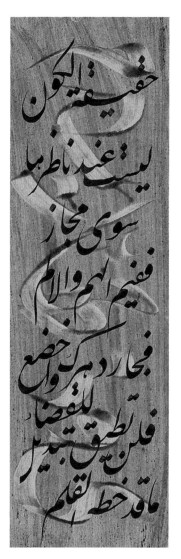

▶ "The reality of the Universe," poem by Omar Khayyam. Nasta'liq style.

◀ Letters in free style.

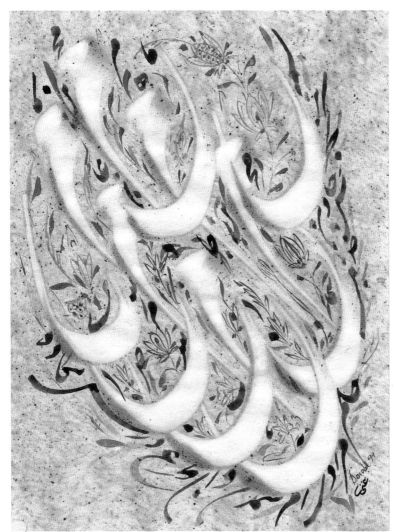

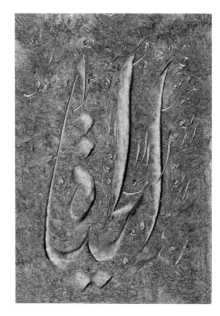

▲ Poem about life, by Ghani Alani.

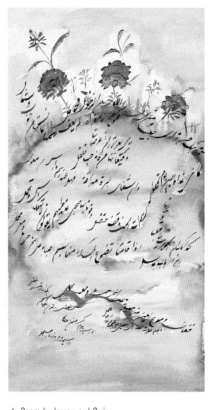

▲ Poem by Imrou oul Qais (500–540 CE). Extract from his Mu'allaqat "The Break of Day." Nasta'liq style.

Ghani Alani, pilgrim of calm, magician of words . . .

Poet, calligrapher, illuminator, law professional, university professor . . . it is impossible to cite all the areas in which Ghani Alani excels.

Alani divides his time between teaching and creation. His paintings are in museums throughout the world, and several films have been made about his work. Born in Iraq in 1937, he grew up in the marshy region around Baghdad, near the reeds that grow along the banks of the Tigris. When he was twelve he became the disciple of H. el Badadi, the grand master of the School of Baghdad. Alani followed several years of apprenticeship before reaching consecration: the Ijazé. This calligraphy diploma, awarded by a master to his best student and unique successor, authorizes him to sign his own works. In 1975, Alani received a second Ijazé from H. el Hamedi, master of the School of Turkey. Alani also has master of arts degrees in illumination and in plastic arts, and holds a doctorate in law.

75

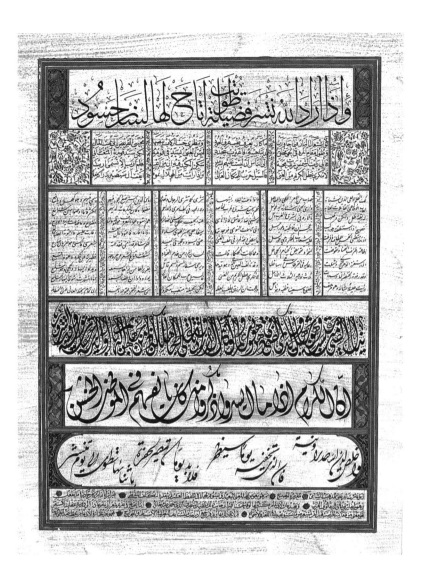

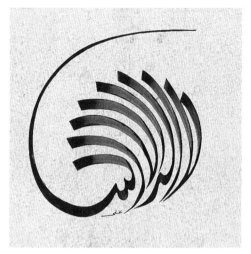

◀ *Calligraphy forms in their relation to poetic meter.*

▲ *"No divinity if not God." The form, invented by the author, is written in a spiral.*

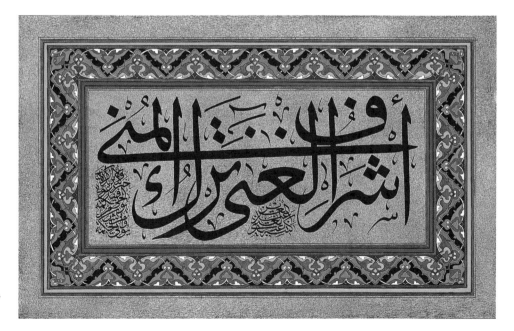

▶ *Proverb from the book The Voice of Eloquence: "The noblest of riches is to determine one's own desires." Thuluth style.*

76

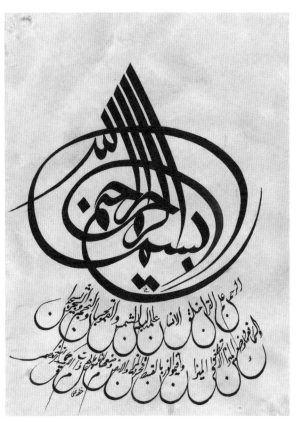

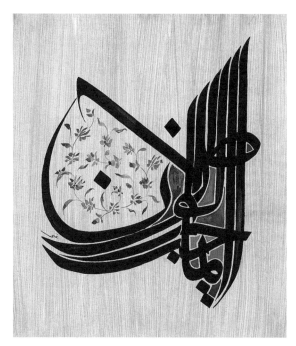

◄ *"The Merciful." Style inspired by Tughra. The repetition of the letter Nun gives the composition rhythm.*

▲ *"Nostalgia." Thuluth style.*

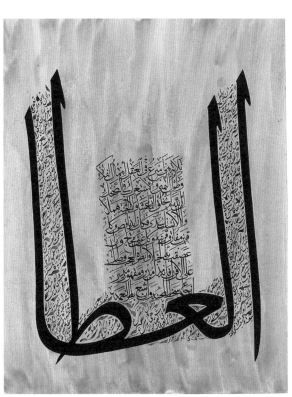

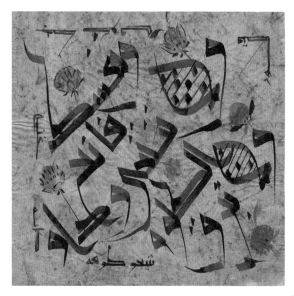

▲ *Wise words by Djahith, tenth-century philosopher (in the year of Hegira 190–255). Muhaqaq style.*

▲ *"Soul and satisfaction." Poem by Tarafa (453–569 CE). Kufic style, created by G. Alani.*

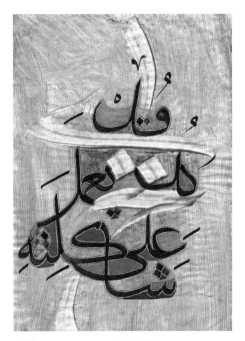

▲ *"Everyone creates according to his own image." Thuluth style.*

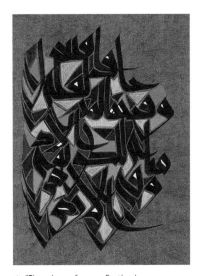

▲ *"There is a refuge on Earth where a generous man can keep safe from offense. It is a haven for him who fears hate." Shanfara, a pre-Islamic wandering poet. Kufic style.*

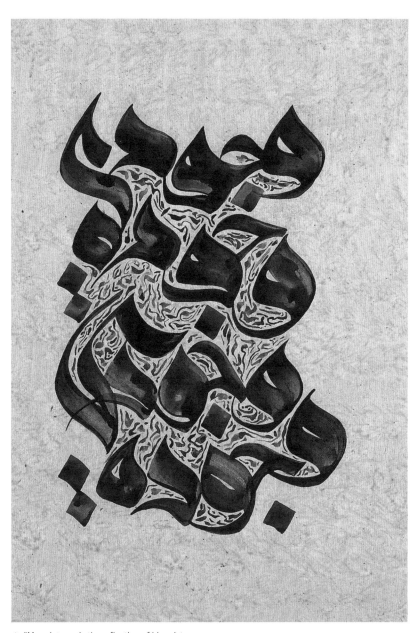

▲ *"My existence is the reflection of his existence. My goodness is the reflection of his goodness."[1] A play of words for a "play of styles." Style inspired by a script called Sunbily (which means "sword" in Arabic).*

1. "Existence" and "goodness" share the same word in Arabic.

GLOSSARY

▲ *Fragments of* The Epic of Gilgamesh.
Calligraphy on papyrus.
The use of Kufic in a cuneiform-like
way can be seen here.

▲ *The sura "Lily," on*
parchment.

Body: the volume of a letter, forming a properly proportioned entity.

Dot: diamond drawn with the "full" of the qalam's nib, which determines the calligraphy style. The dot is also the unit of measure of the letters and the sign that distinguishes one letter from another.

Downstroke: the thickest part of a line made by a qalam.

El Khatt: the Arabic word for the Art of Writing (calligraphy). It can also mean line, trace, etc.

Flourish: a fast, sure stroke at the end of a pointed letter, called *chazia*, or "spark." The end of Ra, for example.

"Full": the bevel-headed nib of the qalam, which forms an upper edge called the "top tooth" and a lower edge called the "bottom tooth."

Ijazé: formal permission to a calligrapher to sign his own compositions, given by the master to his student, by integrating him into the line of masters. The student has the duty to transmit the art to future generations.

Illumination: decoration of the lines with colors. This art was developed alongside calligraphy.

Line: a mark that exceeds the length of a dot or of a succession of dots. It can be a component part of a letter, or a page of calligraphy.

Linking: the system in Arabic script of joining one letter to another, resulting in letters at the beginning, in the middle, and in the final position. The letters Alif, Dal, Ra, and Wau only link on the left side.

Mu'allaqat: a pre-Islamic poetical tradition also called the Seven Odes, where poets come together in a competition. The winning text, written in angular calligraphy, is then hung from the walls of the Ka'aba at the Mecca.

Perfect proportion: an aesthetic theory concerning all the fields of expression (arts, science, literature). In calligraphy, it involves harmonizing the different parts of a letter (head, body, downstroke). For example, the head of Alif represents one-eighth of its body.

Qalam: the calligrapher's principal instrument, traditionally made of reed, sculpted in accordance with the style of the script. It can also be made of other materials like metal or wood.

Slit: the opening in the center of the qalam's nib, which should not surpass the diameter of the reed. It helps with the ink flow.

Stave: horizontal parallel lines drawn on three levels. The principal part of the letters rests on the upper line (Alif, for example); the secondary part rests on the lower line (Jim, for example); and the letters are linked on the medial line.

Style: varieties of script that form an angular or cursive family. We count seven main styles.

Upstroke: the thickness of the nib of the qalam which gives the thinnest line.

Vocalization marks: also called "vowel marks." A system of symbols representing sounds, and placed on or under the consonants.

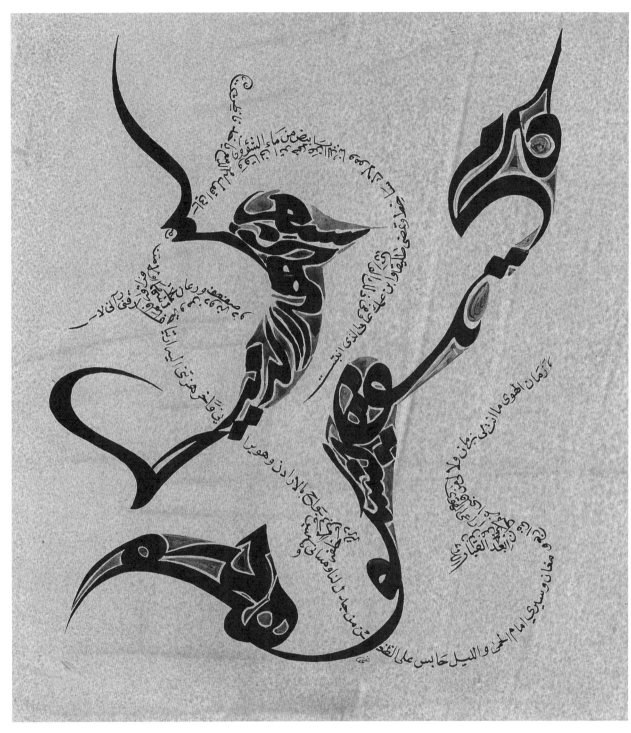

▲ *"Dance of the Letter."*
Illuminated calligraphy.